MAKE GREAT ART ON YOUR iPAD

MAKE GREAT ART ON YOUR iPAD

Paint • Draw • Share

Alison Jardine

ilex

An Hachette UK Company
www.hachette.co.uk

First published in the United Kingdom in 2017 by
ILEX, a division of Octopus Publishing Group Ltd
Octopus Publishing Group
Carmelite House
50 Victoria Embankment
London, EC4Y 0DZ
www.octopusbooks.co.uk
www.octopusbooksusa.com

Distributed in the US by Hachette Book Group
1290 Avenue of the Americas
4th and 5th Floors
New York, NY 10020

Distributed in Canada by Canadian Manda Group
664 Annette St., Toronto, Ontario
Canada M6S 2C8

Publisher: Roly Allen
Editorial Director: Zara Larcombe
Managing Specialist Editor: Frank Gallaugher
Art Director: Julie Weir
Designer: Kate Haynes
Picture Research: Giulia Hetherington
Production Controller: Sarah Kulasek-Boyd

Dosis designed by Edgar Tolentino, refined & extended by
Pablo Impallari, spaced & kerned by Igino Marini iKern.

ISBN 978-1-78157-387-7

A CIP catalog record for this book is available
from the British Library

Printed and bound in China

10 9 8 7 6 5 4 3 2 1

CONTENTS

INTRODUCTION

If you want to start making great art on the iPad, then this book is for you! Even if you have absolutely no prior training, you will learn fundamental art-school principles, a diversity of iPad techniques, and then be ready to take the leap into making original artworks on your iPad.

Innovative in scope, *Make Great Art on Your iPad* is structured around classic themes in art, such as still life, landscape painting, portraiture, and perspective. Often iPad art is associated only with the graphic and illustrative arts found in genres such as video games. This book is grounded firmly in the traditions of the fine art world.

The chapters *Great Composition* and *Color* teach fundamental principles for any kind of art, while *A Sweet Gesture* teaches drawing skills. Other chapters lead you through drawing still lifes, portraits, animals, and challenging objects like glass, plastic, and reflective surfaces. Projects such as "What Would Banksy Do?" puts art into your own urban context, and "Monet's Water Lilies" takes you into the mindset of the Impressionists. In "Hanami & Bokeh," you will travel to the cherry blossom festival in Tokyo; in the perspective projects you will gaze at the magnificent Smoky Mountains, as well as the interior of an art museum. As the skills of each chapter are mastered, there are plenty of projects that will continue to challenge, and, in turn, enrich the proficiencies of even accomplished iPad artists.

To inspire the reader further, "Masterworks" sections introduce exceptional artists who work in traditional media as well as on the iPad. From Banksy's graffiti, Margaret Morrison's pop-inspired hyperrealism, Janet Fish's still lifes, Claerwen James's modern portraits, and Gwen John's paintings of cats, through to Schiele's and Seurat's masterpieces of drawing, the works of these artists give context to the themes of the projects.

As a professional artist, I know the importance of keeping a record of one's ideas, thoughts, and inspirations. The iPad makes a wonderful sketchbook because it has an amazing advantage—it contains a full studio of tools in one clean and portable device. You could sketch (discretely) in a business meeting, while waiting for a doctor's appointment, or on holiday at the beach, gazing at the sunset.

In 2010, I made one painting on my iPad every single day for 365 days. Now, when I look back at it, it is a powerful and moving reminder of what was happening in my life. The iPad can be a visual diary, a personal journal, and a great way to wind down at the end of a busy day.

Make Great Art on Your iPad will teach you all the skills needed to paint or draw in these different situations. If you have ever wanted to learn to draw and paint, whether on the iPad or not, or improve your iPad art skills, keep a sketchbook, or start a visual journal, this is the perfect book.

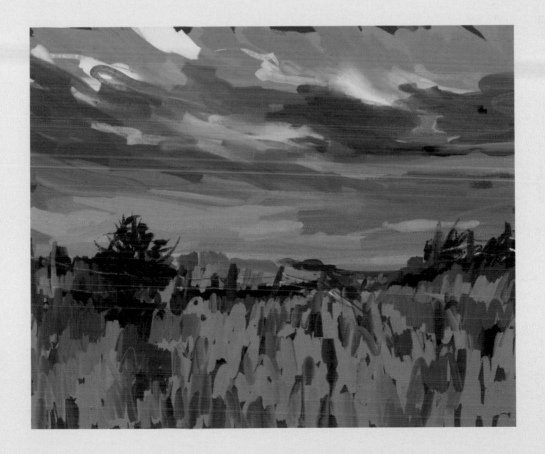

WELCOME TO YOUR NEW STUDIO

A fully stocked studio at your fingertips, the iPad is a unique art tool that you can carry around with you. Acting as both the medium and the gallery, the iPad is like nothing else that exists in art. It raises challenging questions about art—such as the value of uniqueness versus ubiquity, physical versus digital—and blurs the boundaries of traditional media.

There's no longer a need even to buy a sketchbook and keep your pencils sharp. If you enjoy doodling and sketching, would like to improve your drawing ability, keep a visual journal, or want to experiment with making art, your iPad is all you need.

GETTING STARTED: THE APPS.

The first thing to know about art on the iPad is that there are many apps to help you do this. "Apps," short for "applications," work in just the same way as software on your desktop or laptop computer, and they are available through the App Store.

Although this book is titled *Make Great Art on Your iPad*, there is no reason at all why the projects won't work on the Surface or any other tablet or smartphone. While some small specific features may differ, the general principles carry across, and most apps are available across platforms.

I value simplicity and I don't like to have lots of complicated apps on my devices that I rarely use, so I prefer to work with ones that leave me free to create art and not spend time fiddling with awkward technicalities.

To get started, download a copy of Procreate. As with most apps, it is free, but for a small payment you can also have the extra "advanced" features.

The book also features projects using Pen & Ink and ArtRage, the latter being a great all-around app that offers a very satisfying "painterly" experience. For "What Would Banksy Do?" I chose to use ArtStudio, because it is well-suited to graffiti-style spray painting. "Puppy Love" uses Tayasui Sketches Pro, which has a fantastic pattern-based tool and a craft knife.

The important thing is that drawing on the iPad feels intuitive and natural, just like using a sketchbook.

You do not need any art training or experience to enjoy the projects in this book, which have been designed around the fundamental principles of drawing and painting, as taught in art classes, but adapted for the special properties of the iPad format.

The projects are also centered around everyday experiences that most people will encounter during their daily life. From visits to the coffee shop to holidays, to boring meetings, the iPad offers a very pleasurable and convenient way to begin regular journaling or sketching. This activity can help with the stresses and strains of everyday life. It can also help you tap into and reveal your inner artist, and even learn things about yourself.

It has some great advantages too: clean fingers even when creating paintings or charcoals. The ability to work in layers that can later be amended or deleted. And, of course, have I mentioned the "undo" button? I often find myself unconsciously looking for this button when working on an oil painting. If only there were such a thing!

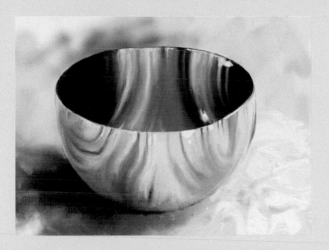

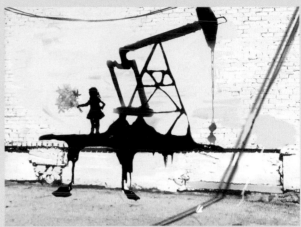

PAINTING AND DRAWING

One huge difference between a laptop or desktop computer and the iPad/smartphone is that with the latter you draw directly onto the screen.

I have the Apple Pencil, but my 365-day iPad project was created with just my fingertips. Back at that time, between 2010–11, styluses were not pressure-sensitive or responsive and I found that they took away from the "art" experience.

However I have since found the Apple Pencil to be truly pressure-sensitive, and I have enjoyed learning how to use it to make marks similar to a real pencil, using side swipes and by varying the density and tone.

The choice is up to you, and fingers will work just fine. The only real difference between the two experiences is that when you use your fingers, the small area around your fingertip is obscured while you draw. Other than that, I find both ways to be equally responsive.

The new apps also offer pressure sensitivity. In some apps, tilting the Pencil changes the way the paint is applied, producing spray rather than a line.

Although the paint tools mimic corporeal media, on the iPad you are in fact painting with light. For color mixing you work with RGB not RYB. In the traditional painting world, artists talk of hue (color), tint (hue with white added), and shade (hue with dark added). In the digital world, the terms most commonly used are luminosity, saturation, light and dark, and color based on the HEX matrix. On the iPad, color mixing can be done by layering different luminous hues on top of each other, either on different layers or by using one the apps that work "wet on wet."

Another advantageous feature is that you can zoom right in as if under a microscope, and then zoom out to look at the whole picture, allowing for detailed, intricate drawings.

The key superpower of the iPad is the ability to layer, and then move between them. Painting in pigment, every brushstroke is a commitment. On the iPad, you can click onto a lower layer and put new tones directly under what has gone before. For an artist, this is freedom!

One final point I'd like to make about the iPad is its connectivity. As soon as you finish an artwork, you can share it all over the web. There are many groups on platforms such as Flickr, or social media, for artists to share their art, and it can be a great way to become introduced to other artists.

I hope you will get into the habit of making iPad art regularly. It combines the psychological benefits of journaling with the joy of self-expression, and if you make art regularly, you also gain the bonus of watching your skills develop and improve.

THINGS YOU CAN'T DO WITH A PENCIL

As I am sure you have realized by now, making art on the iPad is different to using traditional media in several ways. While there are similarities, and many of the tools and brushes seem familiar, there are features of both the apps and the hardware that are specific to the iPad. There are of course a plethora of apps out there, and my selection is by no means exhaustive. As with traditional media, the artist should explore all the options available. Most of these art hacks are common to all apps, with a few exceptions.

BRUSHES

When I made my epic 365-day iPad drawing project, I completed the whole thing with my fingertips. The styluses at the time were unresponsive and for me got in the way. Today, the Apple Pencil and other sensitive styluses have transformed this. You can still use your fingertips of course, and the screen and app will react to pressure in the same way, but the advantage of the stylus is that the tip is very small. This allows you see the area you are working on, which a broad fingertip covers up.

For example, in Procreate, the *Wet Painting* brush responds to how much pressure you use, so you can taper the width of the brushstroke at the beginning and end like when using a real brush. This can be used as a quick way to make shapes, such as a petal form, and textures. If you tilt the Pencil to the side, it sprays a wider ranging paint stroke than if you hold it perpendicular to the screen, where it draws a precise, thin line.

In painting apps such as ArtRage, if you increase the pressure while using the *Oil Paint* brush, the visible "depth" of paint being laid down increases, just like impasto painting. This is satisfyingly similar to the reaction of a real paintbrush loaded with oils, but doesn't require months of training to accomplish.

There is a huge array of different kinds of brushes that exist only on the iPad. Procreate has brushes that draw everything from wood grain to flowers and cubes; there is even a paint texture called "zombie skin." With

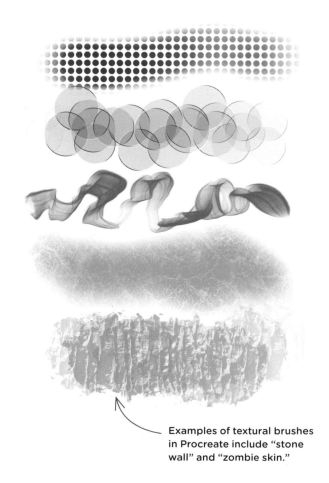

Examples of textural brushes in Procreate include "stone wall" and "zombie skin."

ArtRage features a full range of tools in an easy-access menu bar.

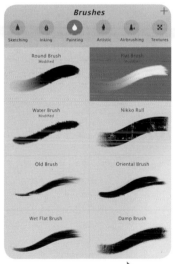

Each of these Brushes in Procreate handles paint differently and gives different effects.

Tayasui Sketches, the artist can choose to draw shapes that are instantly filled with pattern, then cut them out with a virtual knife, resize, rotate, and move them to a new location. Adobe Photoshop Sketch and ArtStudio for iPad have "symmetry modes" that mean whatever you draw on one side will repeat automatically on the other. ArtStudio also has many different textures and shapes for spray paint tools.

All these brushes can be easily altered by size as well as paint opacity, offering a whole new set of interactions and colors. In wet media, this kind of paint handling takes years to learn, and even then the range is much more limited.

Have fun exploring each and every type of brush in all your apps—they can lead you down unexpected paths!

THE ERASER

Some things just work better on an iPad. A great example is erasing. Sure, we can erase a drawing. And yet, it never really erases, does it? There is always at least an indent left on the paper, and the paper surface gets that little bit more worn.

Erasing on the iPad is not just for getting rid of mistakes, however. It is a superlative tool for subtractive drawing, where we carve negative space out of an area of positive space. Used in conjunction with layers, textures and colors can be applied and the eraser then used to cut these separately into shapes. A great use of this is to cut a sharp edge across a loosely painted area of color. This edge will be so sharp that it pushes the object into the visual foreground, because of the principle of line modulation, in which sharp-edged, darker lines come forward, and less dense, thinner lines seem to recede.

If different parts of the painting are put on different layers, then erasing one area has no detrimental effect on the rest of the painting. In real life, this is impossible. If you try to erase an area of a painting, pretty much all the paint in that area will be removed.

Not all erasers are the same of course; apps such as Pen & Ink offer different kinds: some that simply remove, some that smudge, or some that blend. All these operations can be done on the iPad with proficiency and control.

LAYERS

Core to making great art on the iPad is the ability to work in distinct layers. As well as keeping parts of a painting separate from each other for future editing, layers let you stack colors over the top of each other to create new ones, and, by doing so, create visual depth. Layered translucency is somewhat available in traditional wet paint through glazing, but on the iPad it functions amazingly well, because of the layer separation and the backlit screen.

You can sketch on the bottom layer, use it as a guide for your painting on the layers above, and then simply delete the sketch layer. Background colors can be changed for effect, even when the artwork is finished, which can completely alter its appearance.

ZOOM

As someone who wears reading glasses, I always appreciate the fact that with a pinch of the fingers, I can zoom in incredibly close to my pictures and in this way draw with great detail.

IMPORT AND EXPORT

The ability to import files is also valuable. You can import a photograph or sketch as a reference layer, and have it not appear in the final work.

A really wonderful side-effect of this is the color-picking tool. This allows you to sample any area of a photograph, and get that exact hue, shade, or tint copied instantly and accurately to your paintbrush. I wish I could do this in real life for tricky tones such

Using layers, you can easily use an eraser to create sharp edges on an object, without erasing what is beneath, which creates a sense of depth.

as that of the human skin. With this feature you can compile a comprehensive visual dictionary of tints and shades.

Another great thing about iPad art is that you can export a finished painting and import it into another app, to take advantage of the features of that different app. I encourage you to start a painting in one app, then export it into all the other apps, using a different tool in each. The results can be spectacular! I cannot imagine being able to place one drawing on paper through stages of painting, photography, print-making, collage, and so on, and for it to emerge intact.

UNDO

But perhaps the ultimate crowning glory of making art on the iPad is the enduringly marvelous "undo" button. So often in my art studio I have ruined an oil painting with one paint stroke too many and found myself looking for the undo button.

Luckily, on the iPad nothing is final. Some apps let you go back to the start of the session, some allow as few as eight backtracks, but in all of them, undo will at some point save your painting!

Translucent hues laid on different layers create a spectrum of subtle color shifts on the iPad's backlit screen.

DESIGNING AN ARTWORK

Great composition underpins all great works of art. A composition exists in relation to the frame that is around it, whether that be the edge of a piece of paper, or the view of a person looking at a sculpture in the middle of a forest.

Drawing on an iPad, compositions will relate to the particular size of paper or canvas you choose. What makes a great composition is related to what makes something interesting to look at. With composition, artists control the eye movement of the viewer. Composition is fundamentally about the relationship of parts to the whole, and to each other.

In making an artwork, you use line, shape, value, color, texture, form, and space. These elements of composition work together within an artwork, using one or more of these principles: balance, variety, rhythm, movement, emphasis, pattern and proportion, as well as proximity and contrast.

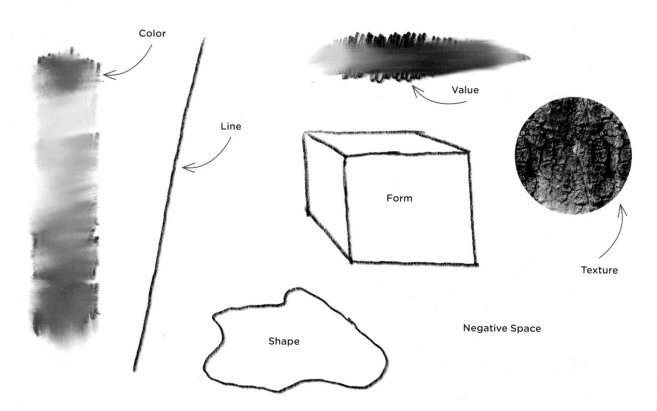

Color

Value

Line

Form

Texture

Shape

Negative Space

Radial compositions radiate out from the center. This one is both radial and symmetrical.

Asymmetrical compositions are divided in half, but are different on each side.

This shows the power of negative versus positive space. Which is dominant here? It is also a symmetrical composition.

Rhythm is created by the repetition of repeated elements or objects, either in a straightforward way (1a1a1a), or irregular (111a111aaaBBBaaa).

Pattern is simply the repetition of elements, such as line or color.

Proportion describes the relationship between subjects or objects and the whole composition, for example, relative sizes or the amount of different colors used on a page.

Proximity can have a great impact—placing things close together makes the eye see them as related, while distance can separate them, and even create tension.

Variety and **unity** are two sides of the same coin: as the name suggests, variety means using a diversity of elements, and unity is achieved when there are just enough similar elements to create a sense of harmony.

Space refers to the sense of depth created by overlapping shapes or lines, or areas that seem to recede.

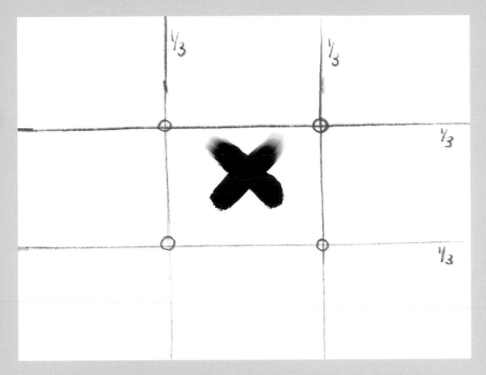

The **"rule of thirds"** can help create dynamic movement in your artwork. Divide your paper into nine equal sections by drawing two vertical lines and two horizontal lines. Objects or subjects placed somewhere around the intersections (circled in red) will produce a more pleasing composition than if placed dead center (on the black X). None of these "rule of thirds" lines run through the center of the work, so it ensures that a composition will be *unbalanced* enough to form a dynamic composition. You want the viewer's eye to travel around the artwork, not get stuck in one dominant place.

These pathways for the eye can be made with pattern, contrast, line, or color. Emphasis can be created by using opposing elements, such as putting a yellow dot on a black background, as in this Abstract Expressionist example.

It might sound extremely complicated, but you will have observed these principles at work in paintings you have seen, even if you couldn't name them.

Compositional studies are a great way to start creating abstract paintings, and I urge you to try all the tools available in the various apps to explore non-representative artworks.

UNDERSTANDING COLOR

Color is a wavelength, and our eyes see the spectrum only between 390–700 nanometers. It has hue (color), saturation (intensity/purity), and value (light/dark).

With pigment paint, mixing the primary colors (red, yellow, blue) makes secondary colors: red + yellow = orange; blue + yellow = green; blue + red = purple. Red + yellow + blue = black. Because the iPad screen uses light not pigment, this doesn't fully work for us.

In the spectrum of light, color is made with red, green, and blue, and adding all these together makes white light. On LCD screens, however, there is a very limited emitted spectrum (gamut) from the backlight, so the iPad doesn't entirely follow this model either.

The iPad is kind of between these two worlds of paint and light. There are some theories of color, however, that remain essential for making great art on the iPad.

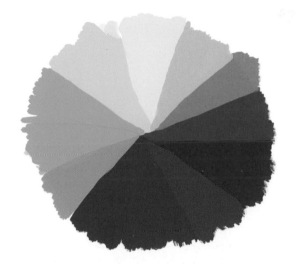

The color wheel shows the spectrum of hues, and is used by artists to make decisions in artworks.

This blue hue decreases in intensity from left to right.

This red hue increases in dark value from left to right to make shades of red.

VALUE

You see form, or three-dimensional shape, easily because light strikes the object and creates a value structure. In this project, you will use just one hue—red—to model a simple sphere with only value changes. I have used ArtRage, although most apps have these tools.

1 Make a dark green background. On a new layer, draw a dark red circle.

2 Draw three successively lighter tints of red on top, oval in shape, and each smaller than the last, placed on the right-hand side where the light is striking the sphere.

 Create a new layer for a shadow: draw a dark oval shadow horizontally from the base, in the opposite direction to the light, and blur the edges with the *Palette Knife tool* set to "edge."

3 On the sphere layer, use the *Palette Knife tool* to blend the edges of the reds into each other.

4 Add a white dot highlight and soften it with the *Palette Knife* set to "soft."

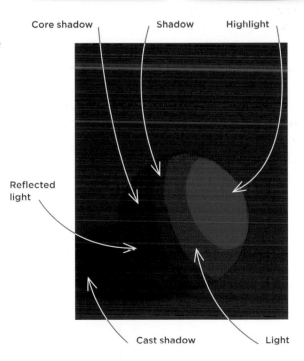

Core shadow Shadow Highlight

Reflected light

Cast shadow Light

COOL, WARM, & COMPLEMENTARY

Simply put, cool colors seem to recede, and warm colors push forward. Red, orange, and yellow are warm; blue, green, and violet are cool. Each of these colors, however, can be warmed up or cooled down by mixing with another color: a red can be made cool if it is tinged with blue. A green tinged with a yellow is warm. Colors that are opposite each other on a color wheel (see page 18) are complementary: yellow—violet; red—green; orange—blue. Placing these next to each other increases their intensity and the contrast.

1 In Procreate, with a *Regular Round Paintbrush* at maximum size and opacity, make a gestural blue color for the background.

2 On a new layer, with a large brush setting, add five dabs of orange of varying sizes, some overlapping, some separated, like oranges on a table.

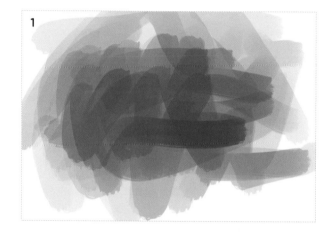

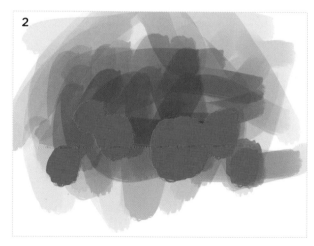

3 With a smaller brush, add darker orange for the core shadows on the left of each of the oranges. Make your brushstrokes follow the roundness of the oranges. Then, select a lighter orange for the lighter areas toward their centers, and lastly add the highlight somewhere on the top-right of each orange. Smooth it together with the *Smudge tool*, and use the *Eraser* to cut smooth edges for the oranges.

4 Finally, on a new layer above the background but below the oranges, add a touch of cast shadow on the "table" under the left side of the oranges. You can add small dark brown crosses on the oranges for the stems. I used a *Pastel tool* for this, because it has a rough texture.

The oranges seem to push forward toward the viewer, because the blue is cool and the orange is warm, and because they are complementary colors. Overlapping the oranges, with larger ones at the front, and the way we modeled the values of the oranges, add to the perceived depth.

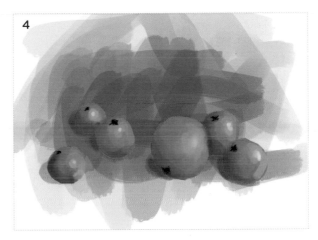

5 Now make the same painting with a warm-colored background—you can simply make a new background for the existing oranges. Use warm pinks, yellows, and oranges. These colors are analogous on the wheel, that is, next to each other.

Notice not only how the new background affects the perceived position of the oranges (they don't come as far forward), but how very warm and happy it seems. It creates a different emotional response than the blue one above.

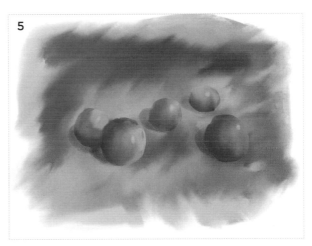

INTENSITY CONTRAST

Here's a project that shows how colors can appear to change when you alter what is next to them. The intensity of a pure hue can be affected by playing with the intensities of surrounding hues. You will place a pure hue on a 50% gray, then a low-intensity hue, and finally a low-intensity complementary hue, and you will change the visual effect significantly.

1 Create a square canvas in Procreate. In your mind, divide the canvas into three columns and rows, vertically and horizontally. In the far left column, draw three squares in a neutral 50% medium gray.

2 In the central column, from top to bottom, make a square of low-intensity red, then one in blue, then yellow. Finally, on the right-hand side, from top to bottom, make a low-intensity green square, then an orange one, then a violet (purple).

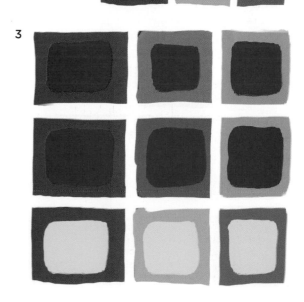

3 Now make a new layer, and on the top row place a smaller square of pure, intense red, the same for each of the top-row squares. On the middle row, place a pure blue, and finally a pure yellow on the bottom. Try to get them roughly the same size in each.

The pure hues seem to change in each square, simply because of what is next to them. These principles are important in making effective artworks with color.

ROTHKO'S ABSTRACTION

Mark Rothko, a leading light of the Abstract Expressionist movement, made huge canvases filled with strips and shapes of color that make the viewer sink into contemplation. He used much of the color theory we have been exploring, including intensity contrast, and the use of warm/cool colors. In addition, his placement often followed the rule of thirds.

1 Open a new portrait-oriented canvas in Procreate. The *Burnt Tree* tool under the Brush icon (*Brushes > Charcoals > Burnt Tree*) makes a good approximation of the roughness of Rothko's paint. Choose a color that suits your mood. For me, it's a dark green. Next, apply a layer of the complentary color—the one opposite on the color wheel—to slightly more than half of the lower canvas.

2 Then, add stripes according to your personal aesthetic. Here, I varied the width and kept all the tones dark except the one bright stripe of pale pink for emphasis and focus

3 To add texture and complexity, I layered some of the pale pink on the dark grey at the top.

FINISHED ARTWORK
Rothko's painting engages the viewer with an ambiguous, absorbing warmth that is almost figurative, using only the rules of composition and color theory.

PRACTICAL PERSPECTIVE

Perspective is a system of making a drawing on a flat canvas or paper look like a three-dimensional space.

When creating a drawing in perspective, it is crucial to remember that it is only YOUR viewpoint that matters. Everything will be drawn in reference to your personal point of view, which is basically your eye-height, straight ahead in the direction you are looking. This is the horizon line, and on it you will find the vanishing point, where all parallel lines converge (such as corridor walls, see page 26).

Of course the iPad is too small to fit a lifesize replica of our view of the world, and so we scale the real world down to fit our paper, making sure everything is scaled down by the same amount.

On the iPad, the small screen size and the need to zoom in and zoom out all the time can make this challenging, as is drawing straight lines freehand. My approach to drawing perspective on an iPad is therefore modified to be workable for the format. In the following project you will use the back wall as a measurement unit to size and place all other items, such as doorways, correctly.

Once you learn this system, you will be able to sketch any one-point perspective view with ease, whether in an airport corridor, a doctor's lounge, or at a street café.

MASTERWORKS

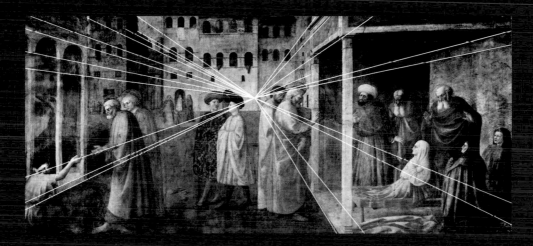

↑ Brunelleschi is credited with first using linear perspective in the 1400s, and it spread slowly across Renaissance Europe. This brought a kind of realism to the visual arts that had been impossible before. Over the centuries, many spectacular masterpieces were created using perspective. Works such as those by Masolino (pictured above) in 1425 show a clear, early use of one-point perspective.

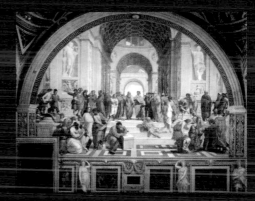

→ Later, during the height of the Renaissance, Raphael made masterful works using sophisticated perspective techniques such as overlapping elements, diminishing their size and color (the farther away something is, the paler and less clear it is), and modulating lines.

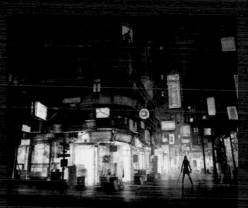

→ Today, perspective is so embedded in our expectations that we hardly notice it, except when artists deliberately decide not to use it or they make a feature out of it. This atmospheric iPad artwork (created with Procreate) by Norwegian artist Nikolai Lockertsen uses one-point perspective to great effect. The woman standing in the foreground is in front of the recessive street. Lockertsen is a master of creating light on the iPad, as we can see from the electric light flooding from the stores. He also expertly uses an overlay of grainy texture, giving the impression of grimy rain.

A SENSE OF PERSPECTIVE

If you have ever looked down a hallway, you have seen one-point perspective with a single point of convergence. It is tricky to understand how to draw it through words alone, so lots of practice is the best teaching method here!

I have worked in Adobe Photoshop Sketch, using the watercolor feature to finish the drawing with touches of color. This project will work in any app, so you can use your favorite.

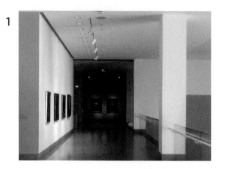

1

1. Find a corridor with a flat back wall, like this one at the Dallas Museum of Art. It also has nice vertical lines (the corner wall and column) close to me, which I will use to make orthogonal lines (diagonal lines that help us plot the perspectival recession accurately).

 The *vanishing point* (VP) is the place on the back wall that aligns with your eyes if you look straight ahead. Point your arms forward to help establish it. This is unique to you—it is your personal perspective—and it is where parallel lines converge, like train tracks in the distance.

2. On a landscape-orientated paper, draw the back plane. Compare its height to the width (square or rectangle?). Since I am standing on the left of the corridor, it is close to the left quadrant of the paper, below the middle. Draw crossing guidelines through the middle of the paper. You can use your hands to frame your view, like the proportions of your paper, and check the wall isn't too big or little.

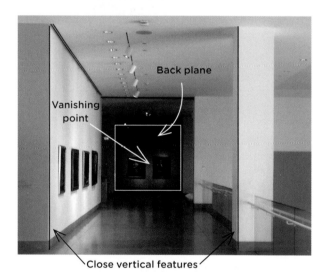

Back plane

Vanishing point

Close vertical features

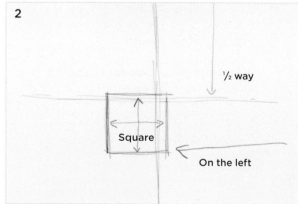

2

½ way

Square

On the left

3 Now we can use this back plane as a unit of measure. To find where the corner of the wall on the left should be placed, measure the gap between it and the back plane using the width of the back plane as one unit.

Find the bottom of the wall by measuring the vertical space between it and the bottom of the back plane. For the wall's height, count up from the bottom, and mark the top of the wall. In this case, it measures three and a half units of the back plane.

Do this for the column on the right too.

4 Mark an "x" to show your vanishing point on the back plane and draw diagonal lines between this and the tops and bottoms of the columns and walls. Turn your iPad to make it easier, and draw with your whole arm, not just your fingers, for easier movement.

5 Now, select a new layer, and begin the final drawing, using your sketchy marks from the layer below as a guide. When you have copied the main lines, delete the sketch layer.

It is very important to note that features like walls and columns will be parallel to the edges of the paper, so try to draw them carefully, to avoid "leaning" as much as possible.

Anything that is perpendicular to (sticks out from) the back plane, such as where the walls meet the floor and the ceiling, will converge on the vanishing point. Corridors that cross our view, like on the left of my photograph, will be horizontal.

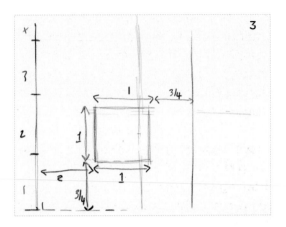

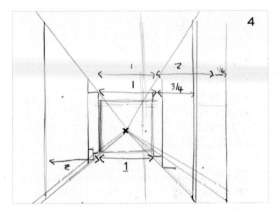

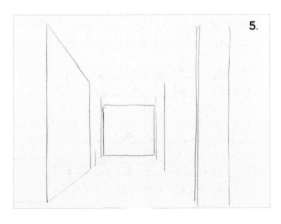

A SENSE OF PERSPECTIVE

6 Look for details, like lights, handrails, and paintings, and remember that they too will follow the rules of convergence and perspective.

7 Now, to finish, use the *Watercolor Brush*. With a translucent flow, start to lay in some of the darker tones. Remember you can overpaint layers to accumulate opacity and darker values. This *Watercolor Brush* acts like real watercolor paints, so the paint continues to spread and mix. You can click the icon of the fan to instantly dry it.

8 Keep it loose, and free. This is a freehand sketch, not a technical drawing. Use the pencil over the top for details like the picture frames.

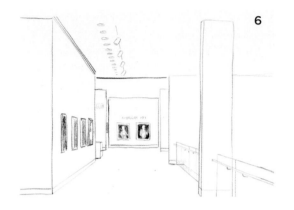

6

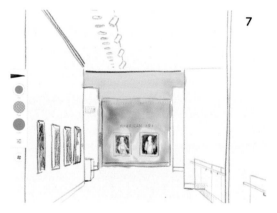

7

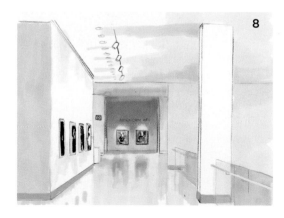

8

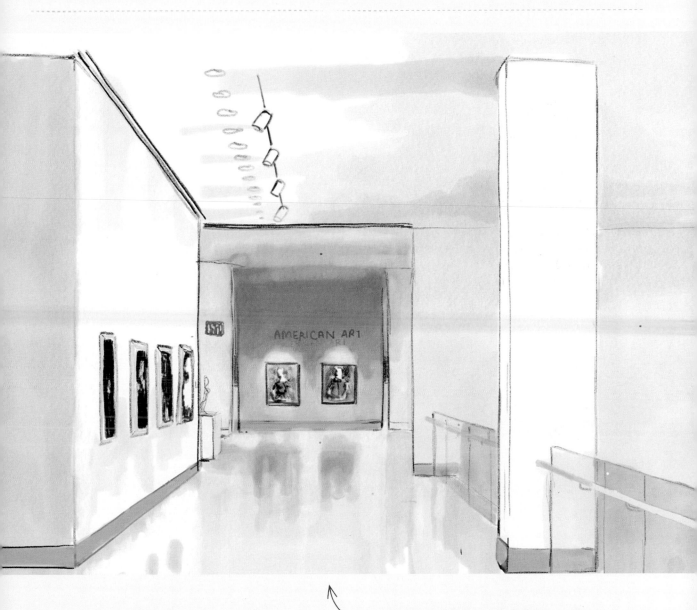

The image shows "AMERICAN ART" text within the gallery scene.

FINISHED ARTWORK
Our final sketch has character through the informal use of line, and the translucent watercolor captures the sense of airy light and shadow.

AERIAL PERSPECTIVE

There are three main principles in aerial perspective: the farther away something is, the less distinct and the more blue it is; things closer to us are bigger than those in the mid-ground and the background; and overlapping features that get increasingly smaller create space.

The indistinctness is caused by decreasing visible contrast between an object and its surroundings, so we can see fewer details. Objects become paler, with more blue tones because of molecules, water vapor, and smoke particles in the air that all scatter the light. This kind of scattered light comprises more short wavelength light (which is why the sky appears blue). British painter J.M.W. Turner was a master of aerial perspective.

This project uses a photograph I took in the Smoky Mountains in the United States, and Adobe Photoshop Sketch, which has a brush that replicates the wet looseness of watercolor.

1 On a new sheet of paper, choose the *Watercolor Brush*, with medium flow in an olive green. Make a diagonal stroke to describe the first mountain slope. Then, add semi-opaque blue for areas of shadow.

2 Over the top, dab and stroke on a brighter green. You are going to create a sense of detail, without actually painting any detail.

The paint stays wet and continues to run and spread, so once you are happy with the form it has taken, press the fan-shaped icon to instantly dry it.

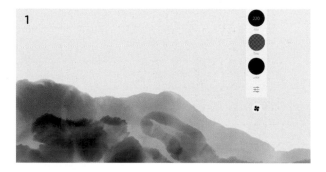

3 Using a smaller brush, layer dark ocher and earth-reds over the green to start making texture in the foreground.

4 Move on to the mid-ground: here's where we start making our hues less intense. On the right-hand side, add a paler green mountain sloping upward to the edge of the paper. Then, select a translucent gray-blue and begin in the center-left, adding the mid-ground mountains. As you lay in the blue, let the white page show in places between your strokes: an easy to way to draw ridges and other features.

5 The mountains already look draped in cloud and atmosphere: enjoy the way the paint swirls, and take advantage of all the little accidents of watercolor paint that add interest. I created the diagonal ridge by using thick, diagonal strokes, and letting the paint mix itself between them.

6 For the third mountain, make the blue paler and a touch more blue. The top edge looks like far away trees; this is just the way the paint swirled itself. The watercolor painter is an opportunist!

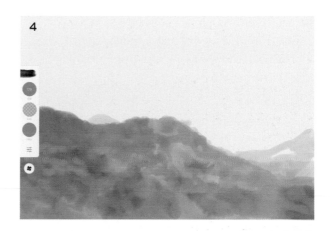

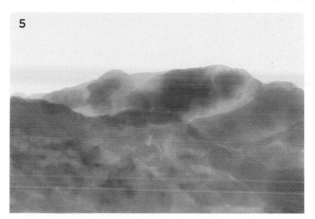

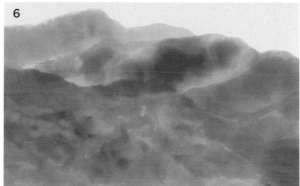

AERIAL PERSPECTIVE

7 The final three mountains that fade into the
distance are made by increasing the amount
of white in the blue, until it almost disappears.

Now, set the paintbrush to a very thin setting and
choose a pale version of the yellow-ocher used in
the foreground. Slowly trace continuous patterns
on the mountain in the mid-ground, over the top
of the blue.

Leave the interior sides of the shadowed ridges
untouched; just embellish the areas where the
light strikes.

The way the blue swirled together in the previous
step has created a sense of clouds.

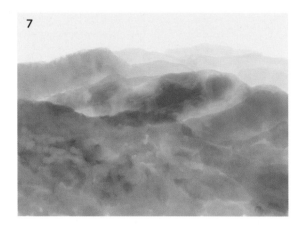

8 Using a very translucent dark gray-blue, set your
brush to a small thickness and dab on texture, like
trees, on the foreground mountain. If you dab with
a slight upward motion, you will create a thinner
oval, more like a tree form.

On the mid-ground mountain to the right, use a
thinned mid-green and an even smaller brush to
dab on vague textural forest shapes. Glaze this
color thinly over the mountain in the mid-ground,
on the left.

9 Using a deep navy blue, on a very light flow, and
with a wide brush, create a new layer and then glaze
over the foreground mountain, all the way down to
the right of the picture.

Leave a couple of diagonals untouched, as if light
is hitting the ridges of the mountain. By darkening
the foreground, it brings it closer to the viewer. By
doing it on a separate layer, it acts like a glaze rather
than mixing with the existing paint.

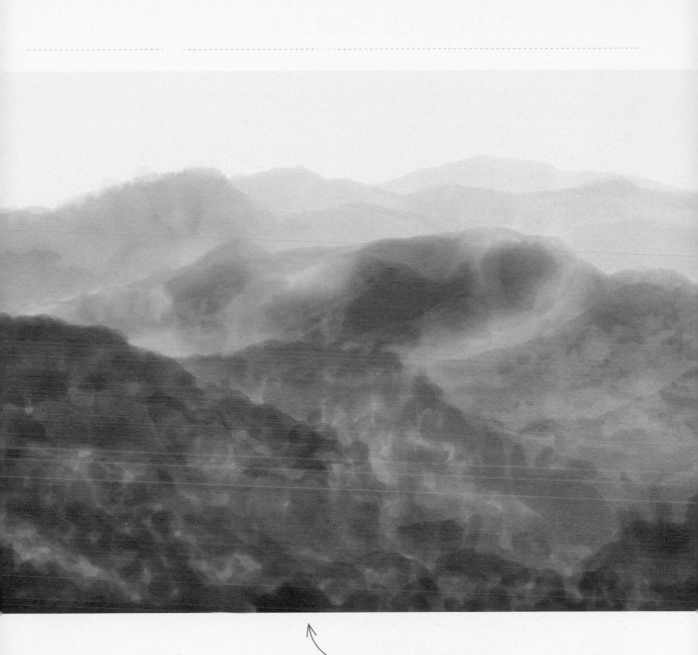

FINISHED ARTWORK
And leave it there. This watercolor sketch features the three elements of aerial perspective—overlapping forms, decreasing contrast, and increasingly pale blue hues.

DRAWING IS SEEING

From ink drops and charcoal powder to thick pencils and felt tips pens, the iPad drawing apps offer amazing similitude to the real media, minus the spills and dirty fingers.

A drawing starts with seeing, which is not as simple as it sounds at all. We perceive by matching input from our senses to pre-conceived "shorthand" ideas, a fast and efficient process. If I ask you to draw a tree from your mind's eye, the image that forms first is most probably a straight brown trunk with a largely circular mass of green at the top.

All artists must learn to see the world as it actually is. Take a moment from your day to observe a real tree: look at the tree roots that dig into the ground and split into branches at the top; the colors and textures of bark; and how light flares and fades in places as the leaves move. This kind of observation will feed into your art.

The second part of drawing is training the eye and hand to work together and turn a four-dimensional experience (including time) into a still two-dimensional drawing or painting.

These projects will lead you through understanding line and value. The contour drawing exercises help link the movement of the hand directly to the movement of the eye, while the time constraints in "One-Minute Portrait" mean you stop hesitating and just draw. Finally, adding value to your lines adds the element of form through light and shadow.

MASTERWORKS

→ Egon Schiele (1890–1918) was a master of the line, breathing life into them with tenderness or tension. This contour drawing conveys the complexity of these two people and their poses with elegant simplicity and brevity.

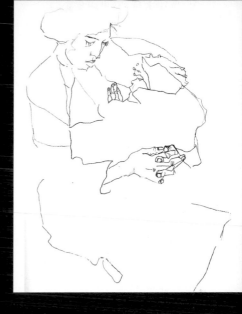

↓ In Cy Twombly's *Untitled* (1968) there is no technical rendering of an object, but the powerful artistic expression remains through line energy. We can feel the physical gesture he must have used to make these energetic, frantic lines that are suggestive of writing but without any concrete forms. He keeps the viewer wondering.

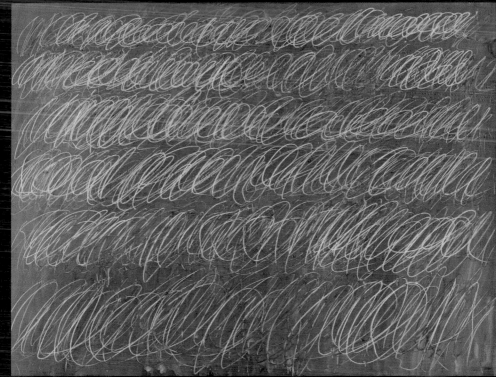

BLIND CONTOUR

Blind contour drawing is like doodling with a purpose, and much more fun than pre-printed coloring books! I used the Pen & Ink app for this project, using a pencil tool. To follow along, no matter where you are, find something in front of you to draw—a person, a glass, a bunch of flowers, a parked car—literally anything at all. Here's the deal—you can't look at what you draw until you have finished.

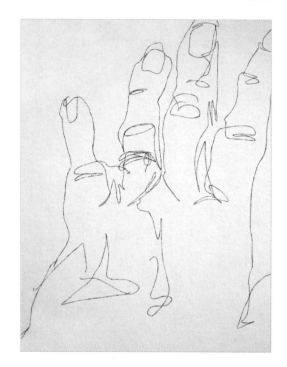

With your eyes, find a place on your subject to begin and let your hand slowly trace the contour lines; these are the edges of things, where two forms, colors, or textures meet.

If you have to take off the pencil and put it down somewhere else, that's ok—just make the best guess you can without looking at your drawing!

I recommend you do this for no more than a few minutes at a time. The results are often funny and at the same time they also show how much energy and descriptiveness a line can have.

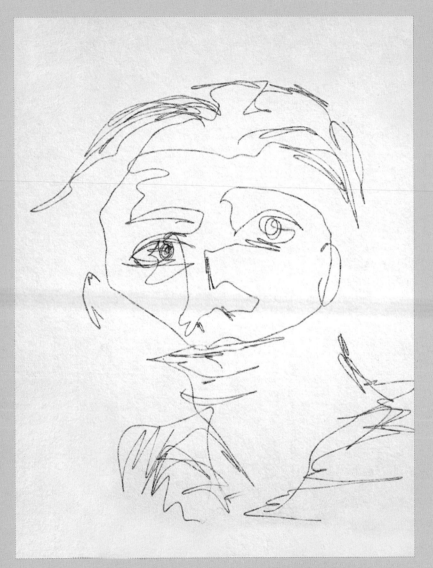

FINISHED ARTWORK

With blind contour drawing, as the eye moves
over an object, the hand follows on the paper,
training the eye and hand to work together.
I recommend trying this exercise many times!

ONE-MINUTE PORTRAIT

One minute is not a lot of time—really. I recently drew portraits for patrons at a science museum, and I developed a shorthand technique to draw each portrait in around a minute or so. Drawing fast and under pressure, there is only time for the essential lines. The *Charcoal Pencil tool* in the Pen & Ink app lends itself to making fast, attractive sketches, and it naturally creates hairlike lines, which saves time on eyebrows and lashes. I found that most people love being drawn, and this quick technique is a great way to amuse your friends and guests, or to pass time meaningfully while sitting in an airport lounge or café.

For this drawing, I started with the shape of the head, just using the *Charcoal Pencil tool*. The eyes are blobs of the *Ink Brush*, and I used the *Eraser* to create the eyelids, and then the highlight. I added shadow simply by smudging pencil lines. I drew a line between the lips, which often turn down at the ends, rather than concentrating on the outer lip shape.

1 Find a person to draw, or even just find a photo from the internet to practice. It's the looking that really matters. As you practice this, you will learn to capture something about their face that is individual. Perhaps there is a well-defined chin, wide eyes, a curved nose—but with everyone, the eyes matter.

Start with the eyes: outline the shape of the rim, the eyelid, and the eyebrow. Dab an black ink blot for the irises. Remove the top of the ink circle with the eraser to create the eyelid. Add a highlight by erasing a small dot.

2 Move on to the nose—focus on the line where the nostrils are.

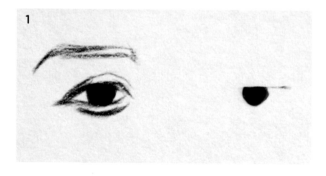

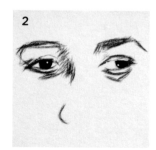

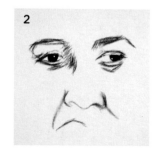

3 Move down to the mouth—draw the central line where the lips meet, then the outer shapes. Mouths often end on the same vertical as the irises. I recommend avoiding teeth!

4 Quickly draw the jaw shape and the sides of the face if you can see them—I am nearly out of time here. Use gestural lines for the hair that follow the hair's pattern.

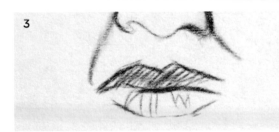

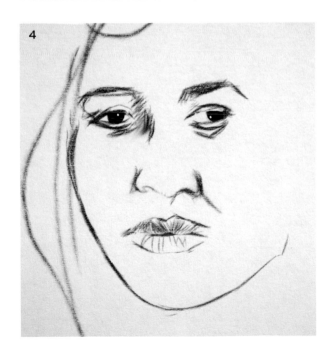

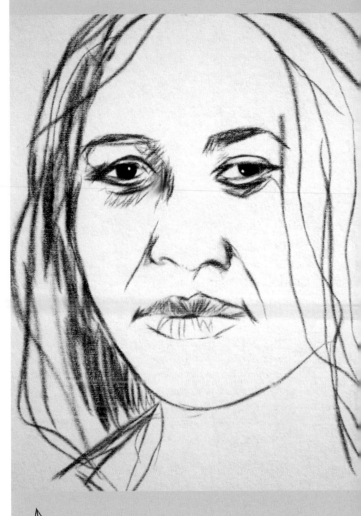

FINISHED ARTWORK
And you're done. I stopped there at just over a minute, with an unfinished but quite representative sketch portrait.

DRAWING ON THE EDGE: CONTOUR

Like "seeing," drawing a line sounds really simple, but this is not the case. Blind contour and contour drawing are great projects to improve these skills.

For this project, you will be drawing a vase of flowers: wherever you go, there are flower arrangements, so let's immortalize them!

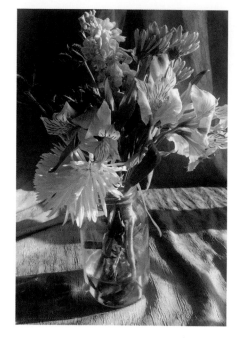

1 Open your preferred drawing app. I have used the Pen & Ink app for this, with two layers. Use the bottom layer to mark out the relative size of the vase and the bunch of flowers. Measure how much of the object is the vase, and how much is the flowers. By setting your thumb at a specific place on the pencil, you can create an ad-hoc unit to measure by. With mine, just fewer than two jar-heights will fit into the total height.

Next, mark how wide the vase is: compare the width to the height of the vase. In this case, the width fits into the height twice, so mark it with lines. I also marked where the jar starts getting smaller toward the rim—your vase may not do this.

2 Now, select the other layer, and let's start drawing. As with the blind contour project, simply pick a spot and start to follow the contour. Focus on the external shape. Keep your eye trained on the jar and flowers, and let your hand slowly follow where your eyes lead.

Then, look for trapped negative spaces within it—areas where you can see through the flowers to the background. This silhouette makes a striking drawing already!

3 Now, delete the layer with the measurements on it, and we have a completed exterior contour. Next, begin work on the interior details. Look at the petals. They are simply shapes placed next to other shapes.

4 Look for directional lines in the flowers, such as these fibers in the leaves, and let your pencil marks follow them to create form.

5 Keep zooming in to work on details, and then out to make sure you are staying within the correct overall proportion.

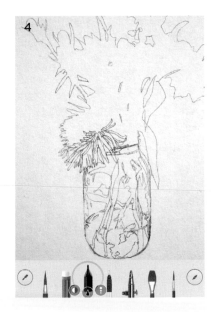

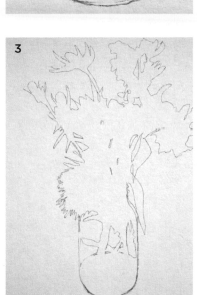

DRAWING ON THE EDGE: CONTOUR

6 Don't overcomplicate the drawing. This thistle can be reduced to simple shapes—smaller ones on top of a larger one.

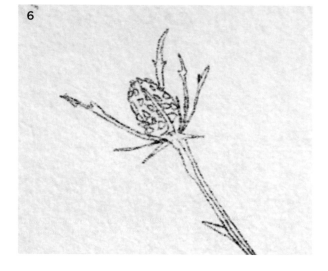
6

> **TIP**
>
> With contour drawing, you don't have to worry about color or tone; you can just move from one shape to the next. It's very calming!

→ **EXTRA PROJECT**
For a fun extra project, why not print this and color it in?

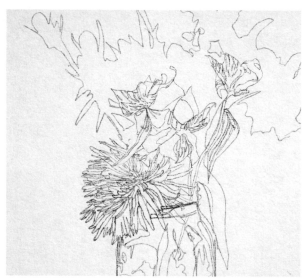

FINISHED ARTWORK
And it is finished. This simple line drawing really brings the flowers to life.

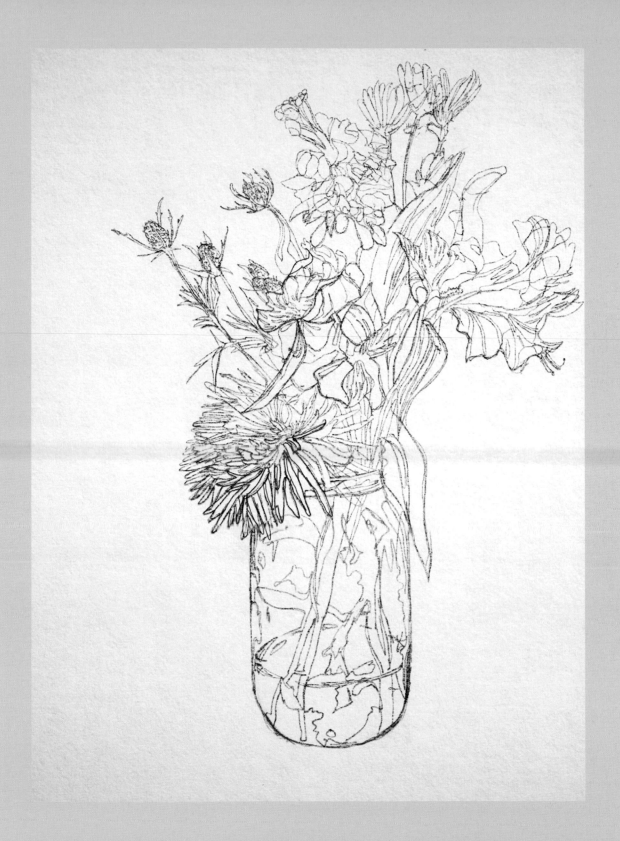

DRAWING VALUE

Value is the relative lightness or darkness of a color. A light value next to a dark one separates objects in space, and graduation of value creates form. This project uses the background paper as the "light" areas, and focuses instead on drawing the areas of shade. This limited range of value will create an atmospheric, three-dimensional drawing.

Find some vegetables—a classic subject for still-life art—to use as subjects (I used radishes and carrots with the greenery still attached). Place them on a table in front of you, making sure they are lit from the side, from a lamp or window. This will create good shadows depicting form.

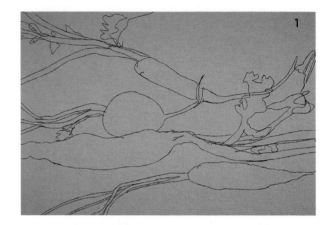

1 Using the Pen & Ink app, set the paper color to a medium brown or gray. Using the *Pencil tool*, make a contour line drawing.

2 There are many ways to create value when drawing, such as cross-hatching. But shading can take a very long time. Luckily, Pen & Ink has a *Graphite Brush* that makes it quick and easy. Click on the pencil icon, select the *Graphite Brush* that has the lightest setting.

3 Start to describe the shadows underneath the vegetables (the cast shadows), using the *white Pencil Eraser* to tidy up the edges or overspill.

Thin shadows are easily created by using the eraser to cut the shadow-shape from the graphite spray.

4 Next, start adding the shadows on the vegetables
 themselves: work from the darkest part of the
 shadow first (the core shadow). Changing the
 pressure and angle of your Apple Pencil changes
 the density of graphite with this tool. Look
 carefully at how the dark shadow gradually gets
 lighter as it moves toward the light, and is darker
 toward the bottom of the object. Lighten the
 pressure as you press, and lighten the amount of
 graphite to get a gentle gradient, not a hard edge.

 In some areas, the core shadow and the cast shadow
 are exactly the same value, and the edge of the
 vegetable almost vanishes. Similarly, in other areas
 the light top areas disappear into the background,
 and the edge becomes lost.

5 Use the *Pencil* to add the darker textural lines that
 describe the surface of the carrot, and the eraser to
 draw the uneven striations and grooves that catch
 the light.

6 The light on the carrot in front of the shadowed
 round radish implies a line and creates distance.
 Similarly, the top of the radish is just blank paper
 edged by the shadow of another carrot.

 Building the lines on the carrots by layering lines
 on top of each other creates a great texture. Work
 successively over the top, with smaller and smaller
 lines.

7 Finish by adding observations of the stems
 and leaves.

FINISHED ARTWORK
We now have a fully rendered
dimensional drawing created by
only drawing the shadow values.

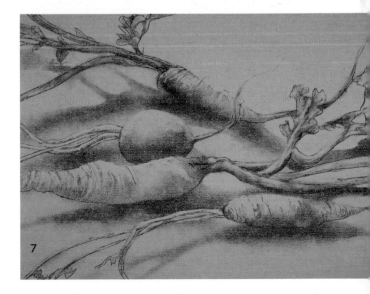

STILL LIFE

The still life genre really came to prominence in the 17th century, and continued to be popular as each new painting movement or style that came along released their own versions. In art schools, still lifes are key to teaching drawing and painting.

The contents of a still life are chosen incredibly carefully, often being replete with symbolism and meaning. Often, still life shows the everyday, such as food from the kitchen, open windows, and flowers. Others have darker connotations, featuring skulls, scientific equipment, and mysterious open books. Flowers remain a popular subject, as does food.

As well as the objects themselves, the lighting is a critical part of a still life, not just in terms of modeling form, but also in terms of expression. Consider the visual and emotional difference between candlelight and a store's fluorescent strip lighting.

The other really key component of a still life is the cropping—that is, how close-up is it going to be? Cropping and composition go hand-in-hand, and by controlling these, meanings can be altered, and tension and atmosphere created. In the "Masterwork" example here, some of Fish's objects go off the edge of the picture plane, and some are entirely enclosed within it; the shadows and reflections head out of the frame.

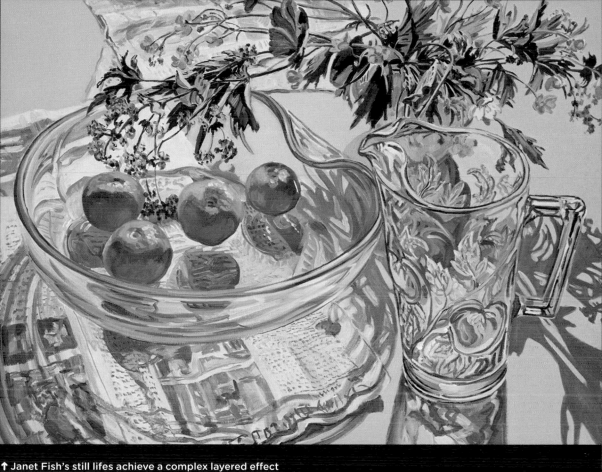

↑ Janet Fish's still lifes achieve a complex layered effect
by overlapping objects, both front to back, and top to
bottom. She overlaps also the translucencies, shadows,
and reflections. The dominant impression of this painting
is of the sense of light passing through glass. In a way,
that is Fish's subject.

In 1968, the artist said that, "The reason for painting glass
was to totally focus on light, and the glass held the light . . .
[Still life is] really as much painting life as anything else . . .

OUR NOT-SO-STILL LIFE

Coffee shops often have great wifi, and are also great places to sketch—faces, postures, objects, and so on. This project is of a very refreshing green iced tea I had on a hot summer day. It uses Procreate, which has a special brush setting we are going to try.

1 First, take three simple measurements. Mark where you want the bottom and top of the cup to be. Then, use your stylus as a ruler: hold it horizontally in front of the cup, align the end to the bottom edge of the cup, and position your thumb where the other edge is. Turn this measure vertically, and count how many times it fits into the height. Closing one eye really helps!

In this case, it fits three and a bit times. Make the bottom of your cup a size that fits into the height of your drawing just over three times.

2 Next, look at the angle of the sides of the cup: hold your stylus out again, and turn it until it matches the sides of the cup. Keeping this angle, move your stylus over your drawing, and mark the diagonal.

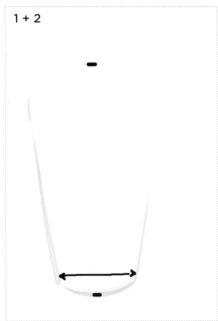

1 + 2

3 For the final measurement, we need to work out how to draw the oval shape that is the top of the cup. This is an "ellipse," and it's quite simple to draw. Close one eye, and imagine the cup is as flat as a TV screen. Then, measure how many times that oval ellipse fits into the total height of the cup. In this case, around five. Mark the bottom of it; the top and sides are already there from your other measurements. To draw a good ellipse, draw a cross through the center. Make gentle curves on the outer edges of this cross, that curve toward the next point. Each quarter should have the same curve as each of the others.

4 Choose the *Water Brush* and slide the toggle button to switch "glazed" on. Start to add patches of color. The green tea isn't very green, and it only goes about halfway up the cup. Try to follow the same curve as the rim of the cup.

5 Use the *Smudge tool* (the index finger icon) to blend the colors together. Set the *Smudge tool* to *Wet Acrylic*, under the *Artistic menu*, for even smudging.

6 Next, select the *Mad Splashes* brush from the *Water menu*.

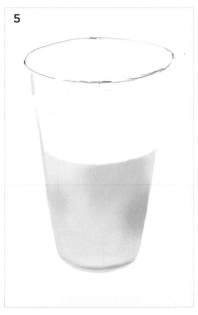

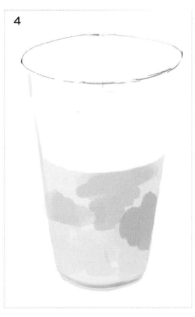

OUR NOT-SO-STILL LIFE

7 Use a small brush setting at first and draw darker brown/gray dots. Increase the size and lightness of the dots, to get a "bubbles" effect. I added a darker line of very small "bubbles" across the top of the tea, for definition. Use the eraser to cut a sharp but varied line where the foam ends.

8 Fill the rest of the cup with translucent gray, and drop down a layer to draw a straight green straw through the middle of the lid. Set the *Round Brush* tool to an appropriate width, and do this in one stroke.

9 Using the *HB Pencil*, draw the dark grooves and plastic details of the lid. I chose to draw my (misspelled!) name, and the black quantity marks, too.

10 On the top layer, draw the green straw over the top of the gray lid, to the middle. Use a pale gray paintbrush to draw the shapes of reflected light on the lid, and around the top.

11 Model the light hitting the straw (lighter on left, darker on the right), and add a shadow in medium translucent gray to the background around the base of the cup, using the *Smudge tool* on the edges.

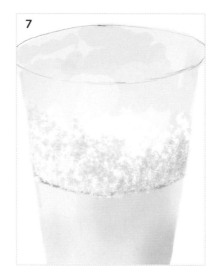

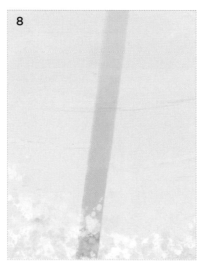

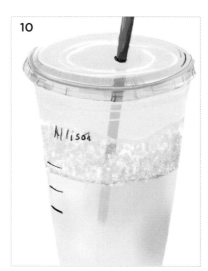

FINISHED ARTWORK
One final effect—use the *Smudge tool* to make the back of the lid, the sides, and the base, slightly out-of-focus. Very refreshing!

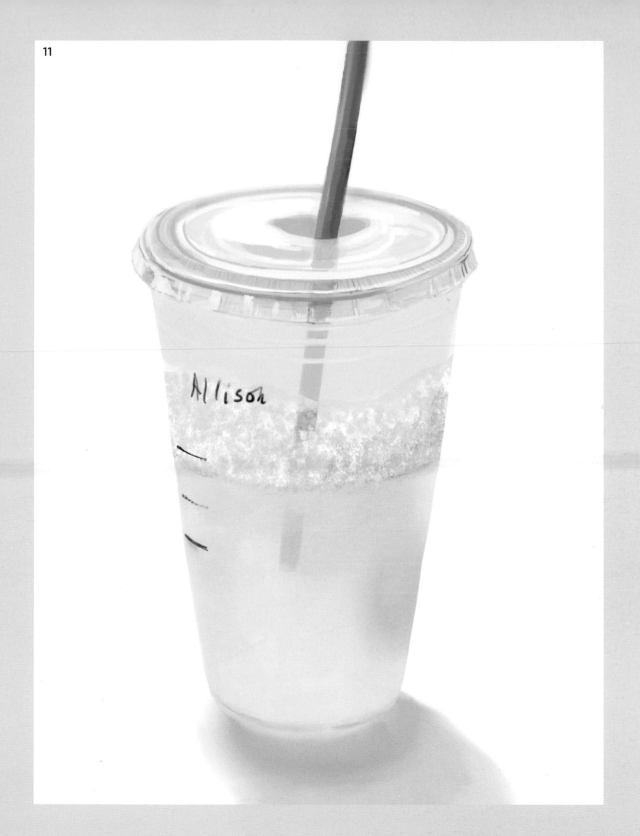

THE BOTTOM OF THE GLASS

Glass refracts and reflects light, as well as being transparent. This complexity can be reduced to very simple lines, making glasses easy subjects that are a joy to draw or paint on the iPad because of the natural translucency of the backlit screen.

I lit these glasses from the side, so the shadows were offset, which helps to create the illusion of depth.

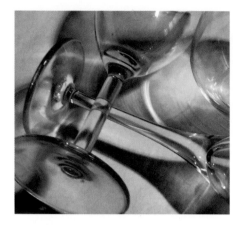

1 Start in Procreate with a square canvas, and set the background to a middle gray.

2 Using a dark gray color with the *Flat Brush*, sketch in the two ellipses and the stems. To help with the ellipse, use the points where they touch the edges of the page as a guide to placement. Don't be afraid of using multiple lines as trial and error to get the right curve.

 Remember that an ellipse is simply a circle seen at an angle, and has smooth curve all around.

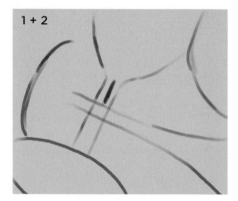

3 On a lower layer, use the *Spray Paint tool* with a slight translucency to start laying in the shadows. Stick to general forms at this stage.

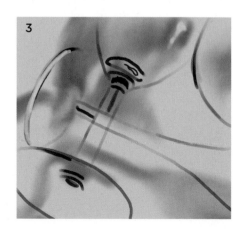

4 After the general mid-gray shadows are added, look for the darker areas and start to build up the gray. To create the lighter curving lines that run through the shadows, use the *Eraser* on medium strength, and subtractively draw them.

This is what the shadow layer looks like on its own; it's almost an abstract painting!

5 Use the *Eraser* to create sharp edges where the shadow is particularly "in focus," such as this dark stem shadow. Use the eraser to curve the shadow when it refracts through the glass stem that crosses over it.

6 Use different strengths and sizes of the *Eraser* to draw the concentric circles passing through all the shadows. These are just simple lines. Let them be a bit wobbly; that's ok—that's what the shadows look like.

THE BOTTOM OF THE GLASS

7 Back on the glass layer, add the lighter highlight lines. Add the values that are lighter than the middle-gray. Expressive squiggles and loose lines are what is needed here. The vertical rim around the base of the glass on the top left has a smaller, brighter, and more opaque reflection on it. This will bring it into focus.

8 I've added darker gray to the rims, and the vertical stem, lighter white highlights to the base top left, and dots of white to the front of the bowl of the glass. As these dots are in front of the wiggly darker lines, they add depth. Vary the width of your lines appropriately, and to add interest.

9 For the glass on the far right, of which we see only the bowl, there really are just a few horizontal lines to draw: medium gray, darker gray, then some bright white dots that form the highlights. These dots create an instant illusion of glass.

At this stage, over the top of the thicker, translucent grays we've been using, look for the thinner, more opaque lines that can add definition.

10 These are the two layers—on the left is the shadow layer, with a few translucent light gray lines, too. On the right are the sharper in-focus lines that create the sense of glass and depth.

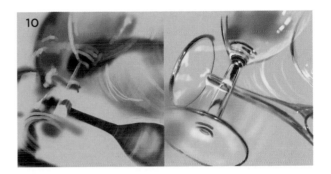

FINISHED ARTWORK

By creating layers of lines, glass becomes quite simple to render. Value (dark to light) and line modulation (sharp small lines through to wide, blurry lines) create a sense of depth and form.

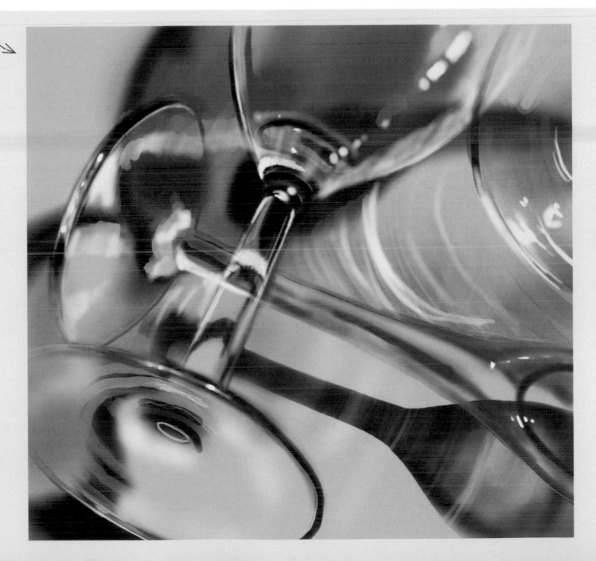

FLOWER POWER

Simple lines can create very expressive, lively paintings that have depth and form. I've used Procreate for this project, as the *Paintbrush tool* is smooth and fluid. If you can work from a live bunch of flowers, that's great, if not, follow along with the steps in this tutorial that use the photograph of flowers on page 30.

1 + 2

1 Create a new canvas in Procreate with a green background. Add several empty layers.

2 Drawing on the middle layer, look for patches of color around the outline of the jar. As you look, notice that there isn't really an outline, just connected shapes in different colors.

3 There is no blending here, just patches of color alongside each other.

3

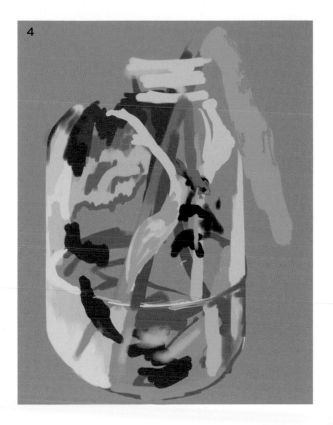

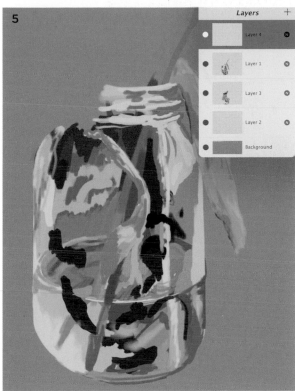

4 The trick to this kind of painting is to make bold strokes of color and lay them next to or on top of each other. It may not look like much now, but it will in the end!

5 Move to lower layers if you want to add strokes behind ones you've already laid down.

6 Consider not only the hue (color), but also the tint (how light it is), and the shade (how dark it is) of your lines. This isn't actually a white flower: notice the blues, greens, and yellowish core. Overlay different-colored strokes on top of each other, from the darker to the lighter colors.

Let the natural taper of the brush tool help you—a single stroke of the pen has a petal shape.

The center petals seem shorter because we can't see their whole shape. Make this your final layer, using short strokes with a flick at the end. This foreshortening creates a sense of volume.

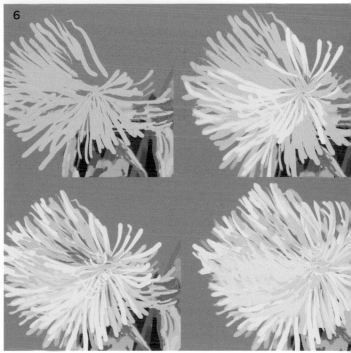

FLOWER POWER

7 I used a translucent *Spray Paint* setting to add touches of yellow highlight to the bottom, background layer. I did this so I would have a light color behind the dark stems I was about to paint, helping to push them forward and make them stand out.

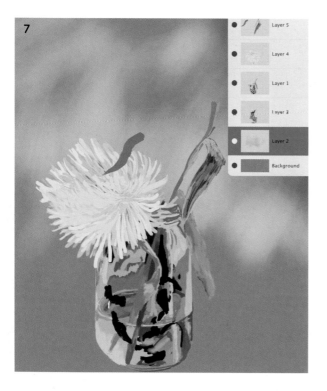

FINISHED ARTWORK

1. These thistles are just dark purple shapes, with dots of lighter purple on top. The leaves are green in front, darker purple at the back.

2. This flower has only general forms, so it seems to be farther away.

3. Layer details over general shapes.

4. Use contour lines that follow the shapes and forms of the leaves and petals.

5. Sharp details bring this flower into focus.

6. Add a shadow; use the *Smudge tool* to make it less well-defined.

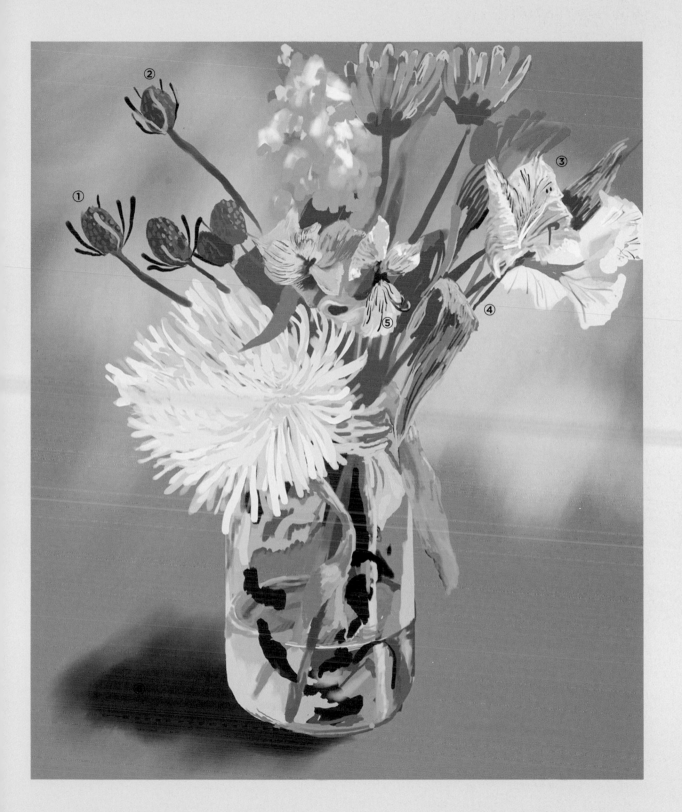

POP ART FOOD

Cakes, donuts, and other treats were made
famous as art objects by Wayne Thiebaud,
who often depicted them on shelves,
repeated over and over. This iPad version
is as fast to make as it is to eat.

1 Using Procreate, create a new square canvas with a
 warm background color. With a *Wide Painting Brush*,
 make four (or more) circles in "donut" brown.

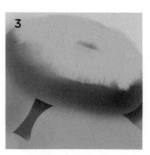

2 Using the *Soft Spray Brush*, use a dark gray/blue
 to create shadow on the bottom of the donuts;
 then, on a lower layer, spray a shadow beneath.
 Remember shadows are directional, so be sure
 and keep the shadows on one side only.

3 Add pink "frosting" on top using the *Flat Brush*.

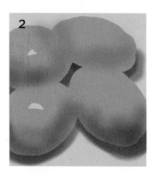

4 Touches of white spray paint add a sheen to
 the icing.

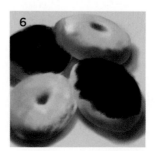

5 Add darker pinks on the outer edges, plus around
 the holes in the middles, to emphasize a sense of
 roundness on the pink frosting. Add texture to the
 brown dough with touches of white and orange.

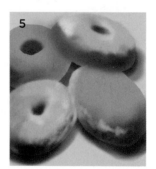

6 Onto the brown frosting.

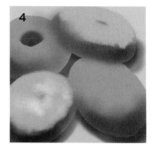

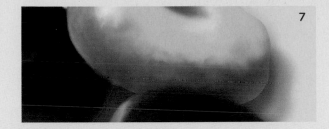

7 Using the *Regular Paintbrush*, add darker oranges around the inner edges of the donuts where they touch each other, to visually separate them and to make a smooth "doughy" edge.

8 Using a small tip setting on the *Regular Paintbrush*, start to dot sprinkles over the top. Vary the translucency simply by varying how hard you tap the brush. This makes the color seem darker or lighter, as well as giving a sense that they are piled on top of one another.

As well as tapping, you can drag the brush slightly to make oval dots that appear to be at an angle to the viewer.

9 Add dots of white as highlights to some of the sprinkles to give a sense of directional light.

FINISHED ARTWORK

They look ready to eat!

OBJECT PAINTINGS

A close-cropped version of a still life, paintings and drawing of objects, often with a photorealist or hyperrealist approach, have grown in popularity since the 1960s. Andy Warhol famously used a simple can of soup as the sole object of a painting, and still today the subjects of object paintings are often the everyday: food, toys, small *objet d'art*. The objects themselves take on new meanings and form as their context is stripped away, often with a wry acknowledgment of the relative unimportance, even silliness, of the subject. The iPad is a great tool for this kind of artwork, the small screen well-suited for this intimate cropping, and photorealistic effects can be quite easily achieved.

The projects in this chapter focus on single objects with a variety of approaches: thick impasto paint, smooth shiny plastic, reflections, and the realism of glazed ceramic. These finishes are combined with the principles of color and drawing, and will build a skill set that means you can paint any object on the iPad.

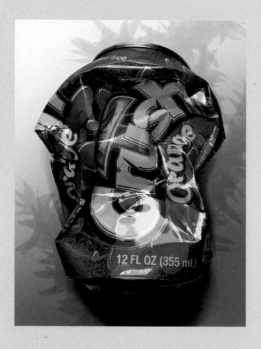

iPad artist Susan Murtaugh uses Autodesk SketchBook in her realistic depictions of the most humble of objects, "trash." She says, "SketchBook is my app of choice. I use the fourth texture tool for most of my work, as it varies both in size and opacity with the pressure-sensitive Apple Pencil. The [SketchBook] airbrush is also the best out of all apps I've played with to make shadows convincing. I always use layers. The rough sketch layer can be moved to the top or bottom of the stack, and turned on and off to make color blocking easier. Layers allow for great freedom and experimentation, I couldn't work without them now."

MASTERWORKS

↑ In this masterful and large-scale oil painting by Margaret Morrison, the candy in the jars become patterns in the abstract sense, yet the reflections and realism pull us back to photography. She told me that she loves painting shiny, reflective, and transparent objects:

"I don't paint the glass, I paint the distortions that I see through the glass and then it materializes on its own . . . like magic. I become completely immersed in analyzing colors, shapes, values; soft versus hard or lost edges. I stop naming 'things' and completely tune into a wordless frame of mind. I work from general to specific, dark up to light, with the last move being the highlight, the icing on the cake."

FULLY LOADED

Loading a brush with paint and laying it thickly on a canvas is called *impasto*. You can do this too with our virtual brushes! The thick paint creates visible lines that you can use as textural contour lines, and by varying the pressure you can create tapering shapes easily, with a single stroke of your brush. This project uses ArtRage.

1. On a new, three-layer canvas (600 x 800 px), create a textured background with dark paint and the *Roller Brush*. On the top layer, choose the *Oil Paint Brush* (square head) with maximum loading, as well as size and pressure. Thinners should be on zero.

 Choose your favorite color and begin making petal shapes. Touch the screen lightly at first, drag your finger or stylus down the screen, then use more pressure and the brush will widen. Ease off, and it will get smaller again. Make each petal with a single brushstroke. Add shadows where petals overlap using thinned, dark paint.

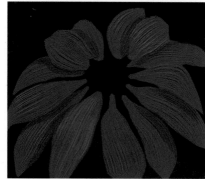

2. Select the *Glitter tool*, with "grit" shape at around 40% in size. Choose a muted yellow and, on the uppermost layer, make the center of the flower (the pistil) in a round or oval shape.

3. Finish the drawing by adding brighter highlights to the pistil, and a green stalk on a lower layer.

FINISHED ARTWORK
Our flower has bloomed!

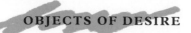

IMPASTO IMPRESSIONISM

When I think of world-famous artist Vincent Van Gogh, my first visual image is of the thick, impasto layers of paint he used. More than any other painter, he is associated with the quality of the surface of the painting, and his unctuous, rough, and expressive strokes, applied like butter. Nothing could be further from the smooth perfect aesthetics of the new media screen, surely? In fact, apps like ArtRage offer the effect of impasto paint for us in the digital age.

This project is an homage to arguably our culture's most popular artist, and a bridge between the aesthetics of the old and new worlds. We will recreate his famous painting of a vase of sunflowers.

1 Open ArtRage and create a canvas around 900 px wide, and 1200 px high. Select the *Square-tipped Oil Painting Brush* with about 8% thinners and 100% loading. Set the pressure to 100%, and auto-clean to "on." The size depends on how large you want your visible brushstrokes to be—50% is a good start.

2 Make the bottom fifth of the canvas a green-yellow, and add the dark yellow bottom of the vase. The vase takes up about one third of the horizontal width: Vincent was in fact very analytical about his painting, despite his apparent impulsiveness.

3 Use a richer green-yellow for the top shape of the vase, and add a thin brown line around its exterior shape. Using a blue-green hue, edge the top of the table and add a thin line that follows the roundness of the vase. Then, sign "Vincent" on the vase, or your own name!

4 On a new layer, lay in the background with a yellow with a higher chroma (more saturated), and also a lighter tint (by adding more white). Van Gogh made many paintings of sunflowers, some with blue backgrounds, as well as green. This project uses a monochromatic, analogous color scheme.

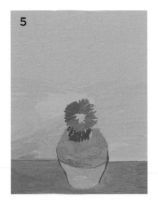

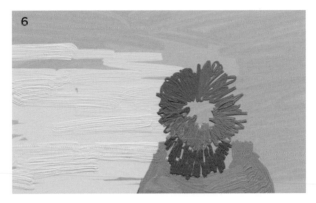

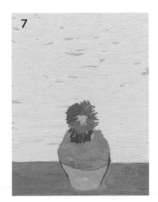

5 When the background is thoroughly filled in with a rich yellow, it needs another layer of even lighter yellow on top to create a "glow" and a sense of layered paint.

6 The yellow background needs to be brighter than the flowers themselves so I added a couple of test flowers here on a new layer to make sure the value contrasts are correct.

7 Leave some of the background peeking through; note the great impasto texture! The daffodil yellow contrasts so well with the darker flowers.

8 Back on the flower layer, set the brush to a thin setting, with full loading, and begin making short lines radiating out from the center of your flowers.

The flowers can be placed anywhere you like, although for this I have followed Vincent's composition pretty closely. I looked at a copy of the painting itself, and skipped around the page making marks where the flowers are. My palette is also similar to Van Gogh's: his yellows are shades—that is, have black added to to them.

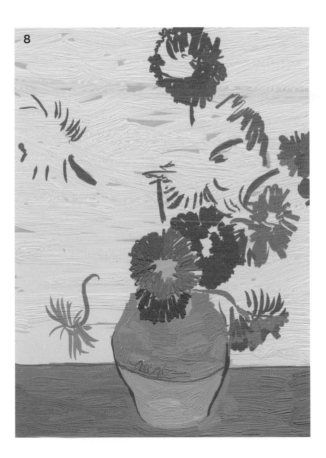

IMPASTO IMPRESSIONISM

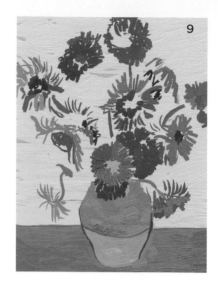

9 The image is starting to emerge from these individual observations of colors and the directionality of the brushstrokes. Although his sunflowers can seem to be simply a single mass of color, closer observation proves otherwise. Building from individual strokes yields a better result.

10 Once you have built up enough individual hues for each flower, use the *Palette Knife* to merge them together. In a sense, we are now making the shapes, or silhouettes, of the sunflowers; on top, we will add more individual strokes for texture.

 Remember to use your *Eraser* to cut out shapes, if your palette-spreading loses form. We can do this because the flowers are on a separate layer, and so our yellow background won't be affected.

11 Add yellow brushstrokes to describe long petals, as well as "dots" to show smaller ones, or ones viewed from an angle. It doesn't have to be too literal, just an impression will do. Begin adding orange and reds to the flowers' centers. I also intensified the green leaves and stems at this stage, too.

12 I added thick brown accents on top of the reds, for a finishing touch.

 In Vincent's original painting, his sunflowers form a "mass" shape in contrast with the bright background, as well as being individual flower forms. By leaving our painting details loose and undeveloped, this work achieves the same indistinct affect.

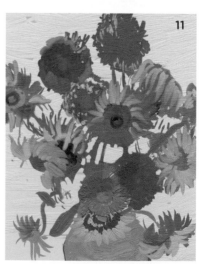

FINISHED ARTWORK

Van Gogh's flowers move into the digital age! I think the artist would be thrilled that even today we are inspired to explore his works on a whole new digital platform.

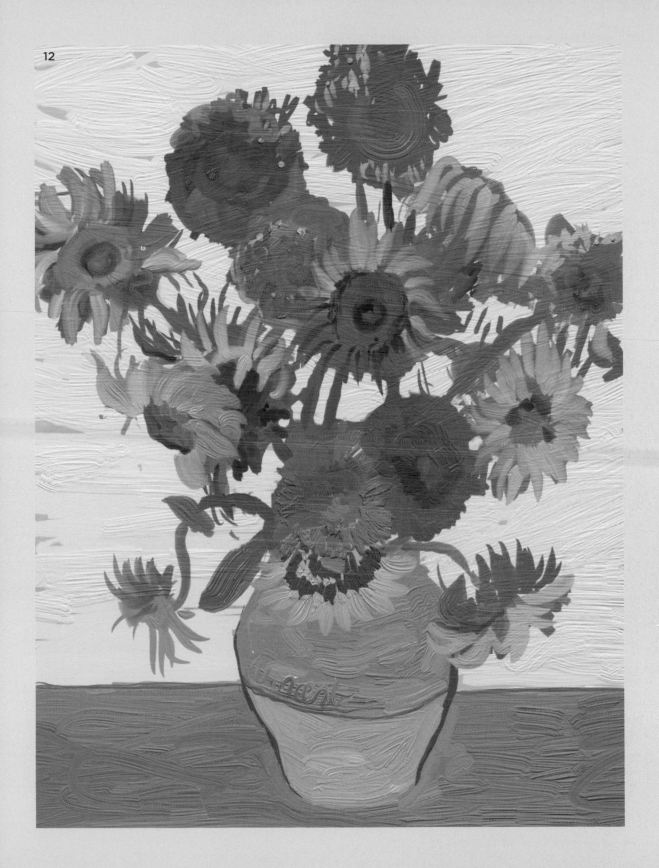

PLASTIC FANTASTIC

An iconic object, the good old plastic garden flamingo still occupies a place of kitsch affection in our hearts, and it's a great object for a photorealistic drawing.

1 Select a rich mid-value pink. Use the *Flat Brush* on full opacity to draw the curve of the neck, the blob of the head, and mass of the body. Do this roughly—you can refine it later with the eraser.

2 Switch to the *Soft Brush* under the *Airbrush tool*. Use a darker value of the same pink with medium opacity on the outside of the head and the middle of the neck. Roughly draw the yellow beak, with a black curving tip, and dot a dark brown eye.

3 With an almost-white pale pink, spray highlights along the underside of the neck, the top left and right of the head, and over the top of the wings.

4 Use darker pink spray paint to model the darker areas—the center of the form is the most vibrant pink, which will make it come forward toward us.

5 Don't worry about "drawing inside the lines"—you can cut sharp edges easily with the *Eraser tool*.

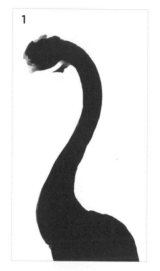

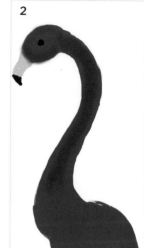

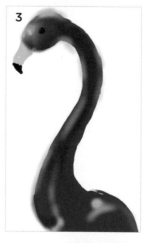

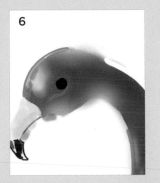

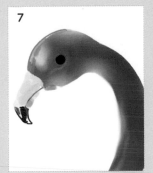

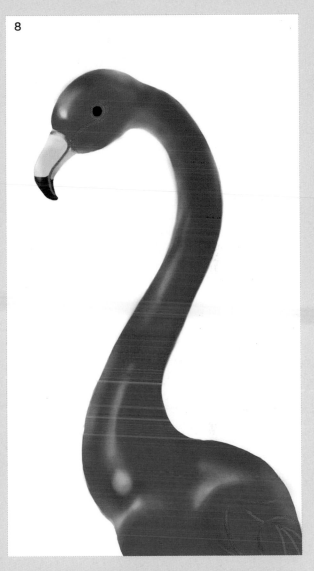

6 Moving on to the head, establish a shape you are happy with: in this case, a sort of oval "lemon" shape. Paint the bottom of the beak a darker yellow.

7 Notice how the very pale pink areas at the top of the head and inner neck seem to merge with the white background. This makes the form appear to curve away from the eye. The edge becomes a little bit lost, which is the natural way that we perceive form.

8 Add some decorative details in a gray-brown color—a swirl around the eye and on the beak; feathers on the top of the wing.

Finally, use the *Eraser* to cut a satisfyingly sharp edge, and bring your plastic icon to life.

FINISHED ARTWORK
This plastic flamingo is made so real by having sharp, erased edges.

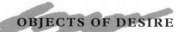
REFLECTIONS

Reflective surfaces aren't affected by light in the same way that non-reflective surfaces are. In drawing terms, we can't create them using the six categories of light (cast shadow, core shadow, mid and halftone light, highlight, and reflected light).

A bowl such as this, that is entirely made of reflective metal, visually comprises only what is around it, as reflections.

For this project, you can recreate my drawing or find a small reflective bowl yourself and place it in a bright room. I have used ArtRage, but you can choose your favorite app.

1 Create a new canvas—in this case I made it slightly wider than high, at 1200 x 1000px—and establish a few layers. Select the bottom layer, which will be the sketch layer.

2 Establish a proportional rectangle by measuring how wide the bowl is versus how tall. In this case, the width is greater than the height. Place your thumb anywhere along your pencil and use the distance between it and the end of the pen as your unit of measure. Simply see how many times it fits into the bowl both horizontally and vertically. In my case, it fits the width three and a half times and the height two and a half times.

1 + 2

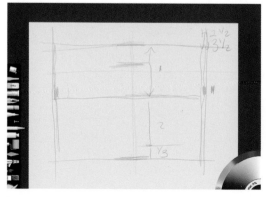

TIP

So much about painting concerns progressing the work from general to particular, gesture to detail, dark to light, or vice versa.

3 Measure the vertical length of the ellipse (the opening)—mine fits into the total height of the bowl around two and a third times. Mark the bottom and top of the ellipse to create a rectangle. Find the center, and make a cross, continuing the lines to the outer edges of the main rectangle. Draw short curves at the points where these lines meet, and join the curves together with longer, continuous, curving lines.

By eye, try to sketch the contour of the sides of the bowl. Refer to your proportional rectangle to see if your curve is roughly symmetrical. Make lots of smaller lines that "seek" the curve—don't be afraid to be messy. These lines will all disappear soon.

4 Select a higher layer and lay in a range of grays, from almost white through to dark gray. Use the *Oil Paint Brush* on a high loading percentage. In this bowl, the stripes of reflected light run vertically and bend around the curves. Try to follow this with your strokes

After achieving a certain thickness, switch from the *Oil Paint Brush* to the *Palette Knife* and start blending.

5 Look carefully for the colors that you find in the bowl. I can see greens, yellows, blues, and browns, as well as variations of white and yellow from the nearby lamp. I also see "stripes" from the rumpled cloth it is standing on.

6 As you lay in the colors, alternate between the *Oil Brush* and the *Palette Knife* to build up the surface quality. I made corrections as I progressed for errors that got introduced during this painting and blending process. Here, by adding pale yellow to the right side, under the rim, I corrected the shape of the ellipse.

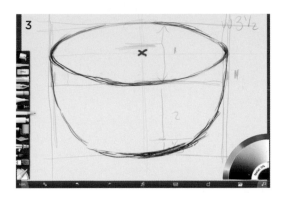

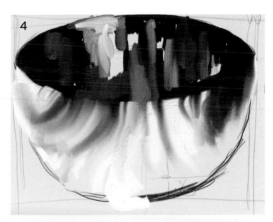

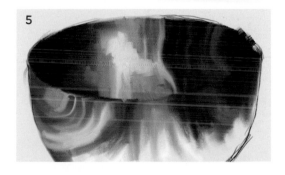

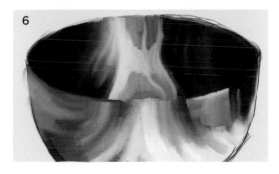

REFLECTIONS

7 Use the *Eraser* to sharpen the upper edge. I made
the sketch layer invisible by selecting that layer and
clicking on the eye icon. I had enough of the form
filled in to work without it.

8 Let's begin the background before we try to finish
the bowl. I have switched to the *Spray Paint tool*,
and selected a layer below the one that contains
the bowl itself. I am mixing warm yellow-whites,
while establishing the shadow areas with dark
yellows and gray.

9 Darken the cast shadow and shaded areas of the
bowl. Add colors to the bowl and blend with the
Palette Knife.

10 It may seem counter-intuitive, but blend the lines
on the exterior of the bowl together. We now have
a general sense of the roundness, the light and dark
of the metallic bowl, and it is ready for the final
detailed reflections.

8
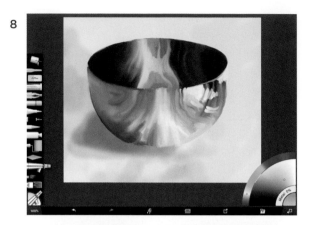

9
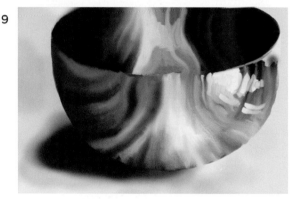

7
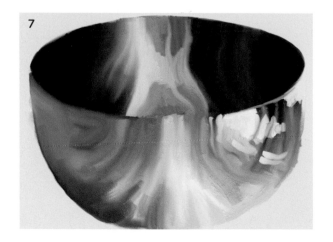

10
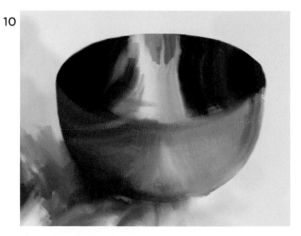

TIP

Remember that the rim is not just a line—it has a shape filled with color—look carefully to see how wide the rim is and match your brushstrokes to this.

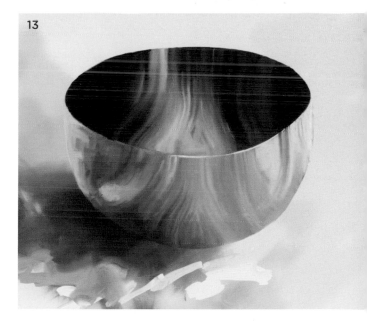

11 Using the *Oil Brush* at around 14%, sharpen and define the inner edge of the bowl, and begin to add new reflections.

The *Felt-tip or Marker tool* in ArtRage is also great for applying thin strokes, as I am starting to do here on the rim, in addition to translucent strokes on the outer and inner bowl.

12 Pull the dark paint down on the inside of the bowl to the lower rim, and then edge over the top of it with a 3% *Round-tipped Brush* (or *Marker tool*) to get the appearance of a sharp edge.

Drawing with the *Marker tool* around the rim has a wonderfully sharp effect. Making the rim lighter than the dark interior intensifies the sense of depth.

13 Use the *Eraser* to define the upper edge. Add more form and details to the cloth the bowl is sitting on.

REFLECTIONS

14 I corrected the bulge in the arc at the bottom of the bowl by selecting the shadow value and using it to paint over the incorrect lighter gray.

15 Here, I added rich yellows and oranges, then softened them with the *Palette Knife*.

16 Using the *Felt-tip* or *Marker tool* on the *Art Pen* setting, look for the highlights and the edges and work around the bowl applying them. Apply the highlights as dots to simulate the metallic texture and give a sense of different light sources.

17 Lastly, add final touches, such as dots of light, shinier reflections, and textures on the cloth. I used a diffuse setting on the *Spray Paint tool* in the upper part of the background to create a hint of *bokeh*, the out-of-focus effect that gives a photographic illusion. This pushes the object closer toward the viewer. I decided to stop here. Stopping is always a decision rather than a certainty.

14

15

16

TIP

An edge is simply two tones next to each other, so you can create them by drawing the background as well as drawing the object.

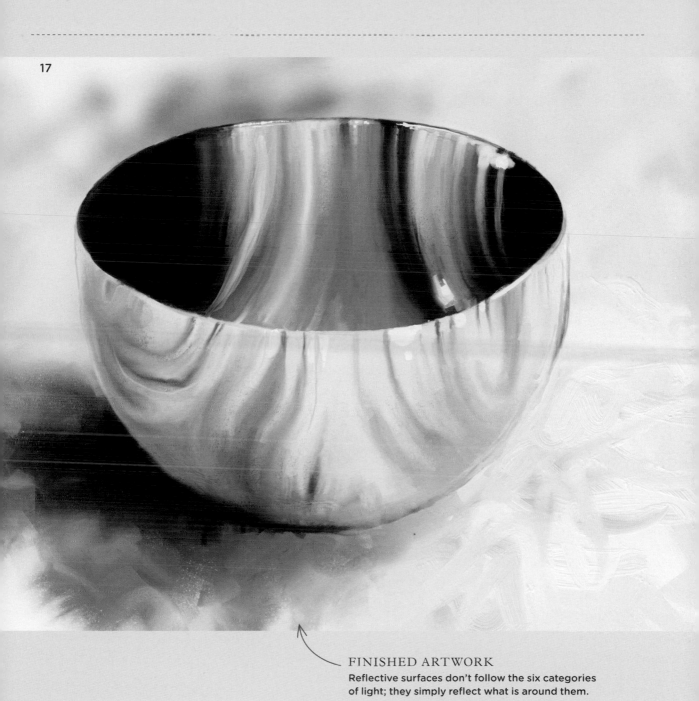

FINISHED ARTWORK
Reflective surfaces don't follow the six categories of light; they simply reflect what is around them.

OBJECT STUDY: LITTLE BLUE JUG

Still-life painting dates back to Ancient Greco-Roman times. It rose to prominence as a distinct artistic genre in the late 16th century.

The iPad is well suited to object studies—the size is ideal for one or two objects, and iPad painting tools convey realism well.

I have used ArtRage here, but you can work in your preferred app. If you work from life, choose a simple object like a jug or cup and use a desk lamp to shine a directional light on the object.

1 Create a new page in portrait orientation, where the height is greater than the width. Create several layers.

2 Working on the middle layer, decide on the scale of the object on your page, ensuring it is not too close to the top or bottom of the page, and mark this with a vertical line.

3 To determine the width, use your pencil as an ad hoc measuring tool. Hold the pencil out in front of you with a straight arm and align the end of the pencil with the left side of the rim, then move your thumb to where the right side of the rim meets your pencil. Keeping your thumb in place, rotate the pencil from horizontal to vertical, and move down the jug, counting how many times that measurement fits into the height. In this case it is three and a bit times. Make little marks on either side of your vertical mark.

4 Hold your pencil out again, and turn it until it aligns with the angle of the sides. Hold that position, and move your pencil in front of the screen, without losing its angle—mark this diagonal on your paper. This is called "angle sighting."

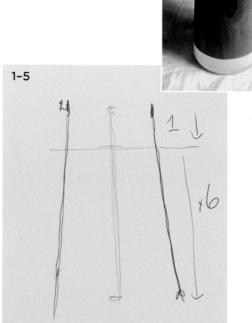

1-5

6

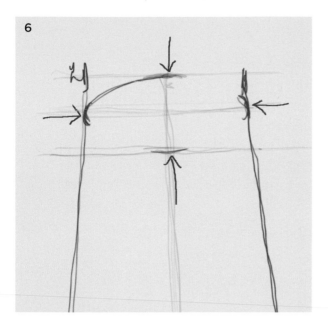

7

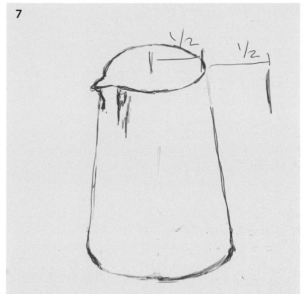

5 Next, make sure the bottom rim of the jug is the right height compared to the overall height of the jug. Hold out your pencil, align the end with the top of the rim, and put your thumb where the bottom is. Slowly move the pencil down the jug, and count how many times that measurement fits into the whole. Here it is around five to six times. Mark this measurement with horizontal lines.

6 Find the middle of the ellipse by dividing it into halves, and draw a cross through the center. Where the cross lines touch the edges, draw curved lines that form these points of the rim. Join them together with curves.

7 Next draw the handle. By making a few different comparisons with the jug, I found that the handle protrudes on the horizontal axis by roughly the same distance as a half of the horizontal ellipse. Delete the measuring lines by erasing or deleting the lower layer, as soon as you no longer need them.

8 Now it's time to paint—choose the *Square Oil Brush*. Switching to the top layer, start to lay down the paint. Although "blue," has a slightly reflective surface lit by a spotlight, there are many variations in hue, tint, and shade.

8

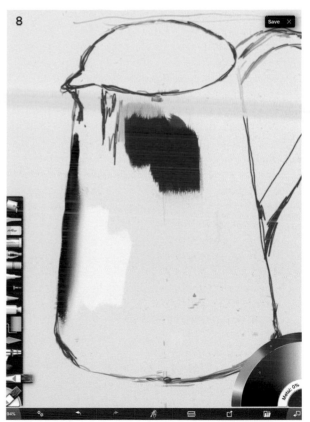

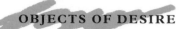

OBJECT STUDY: LITTLE BLUE JUG

9 Observe not only the intrinsic color of the jug, but also the reflections upon it. Look for the six categories of light: highlight, light, shadow, core shadow, reflected light, and cast shadow.

10 Lay on the paint using short strokes. You can use the *Palette Knife tool* (set to zero loading and full pressure) to blend the colors together afterward.

A useful approach to painting is to define the range of values. Ask yourself where the darkest area is. In this case, it is inside the rim. Once identified, you know that all other areas must be lighter.

11 Begin to define the width of the rim with a light, medium-intensity blue, and on top put touches of highlight, where the light hits. These are a very pale blue, rather than white. Remember you can use the eraser to shave off the outer edge and get a good, clean edge.

12 There are reflections along the bottom that we need to depict, and that delicious biscuit-colored exposed clay. The settings in the image are for the light, translucent purple color at the bottom right.

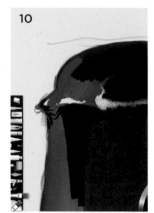

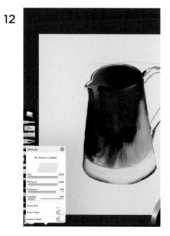

> **TIP**
>
> Since the light hitting this jug is largely from a single spotlight, there is strong directional light, and this kind of light is a great way to create form, as we can see with this handle.

13 For the handle, make a first rendering of the different tints and shades at play.

I used a darker translucent blue over the top to widen the handle at the top and sides, then added light tints and a highlight. Use the *Eraser* to create sharp edges. Keep using the *Palette Knife* to lightly blend the paint.

14 On the body of the jug, work with the *Palette Knife* to smooth those different colors together.

15 The background is a crumpled white linen cloth. White always has interesting tones and hues in it as it reflects the light around it. Switch to the lower layer and begin with large gestural brushstrokes in a translucent light yellow color. Look carefully at the shadowed area—it is almost never pure black. With a yellowish light bulb, the shadow is most likely a bluish color.

16 Use your paint strokes to follow the form of the wrinkles, the angles, the straight lines, the valleys, and the peaks of the cloth. The yellow light bulb is creating rich creamy hues, bright whites, and blue-gray shadows.

17 Create sharp edges for creases in the fabric near the jug, or use the *Palette Knife* to smear and blend places to give the optical illusion of continuous tone.

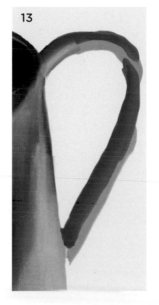
13

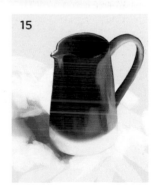
13

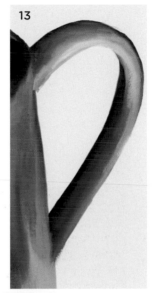
14

15

16 + 17

OBJECT STUDY: LITTLE BLUE JUG

18 Use the *Spray Paint tool* on a diffuse setting to spray over the top of the upper back area of the cloth. By doing this, it appears blurry, and thus seems to push farther back out of our focus, giving an illusion of depth.

19 Use the *Pencil* to start refining the light and the arc along the base. As it curves away at the edge, it gets darker because it is in shadow. The transition to light at the center is gradual. Between the light and dark shades, there is a richer orange color.

20 The next stage is all about the details. The rim of the jug is a shape, with width and form. By setting our brush to the same width, we can create it with a single stroke. You can use the *Color Picker tool* to select colors you have already used; simply hold your stylus or finger on an area of the drawing, and in a second or two the color pops up on the brush.

21 For the handle, I've ensured that the width becomes thinner where it curls back toward the jug. Some highlights in almost-white complete the handle. This same highlight color can be used on the rim of the jug.

22 Over the top of the ocher, begin adding dots of blue to simulate the surface texture of the glaze.

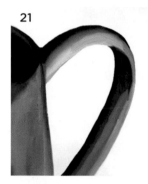

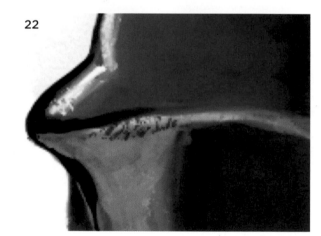

TIP
Use broken lines and dots for your highlights, rather than a continuous line. This looks much more natural and hints at the texture of the clay.

FINISHED ARTWORK
And there, I leave it. Our little blue jug is very realistic, sitting with a sense of gravity on the cloth.

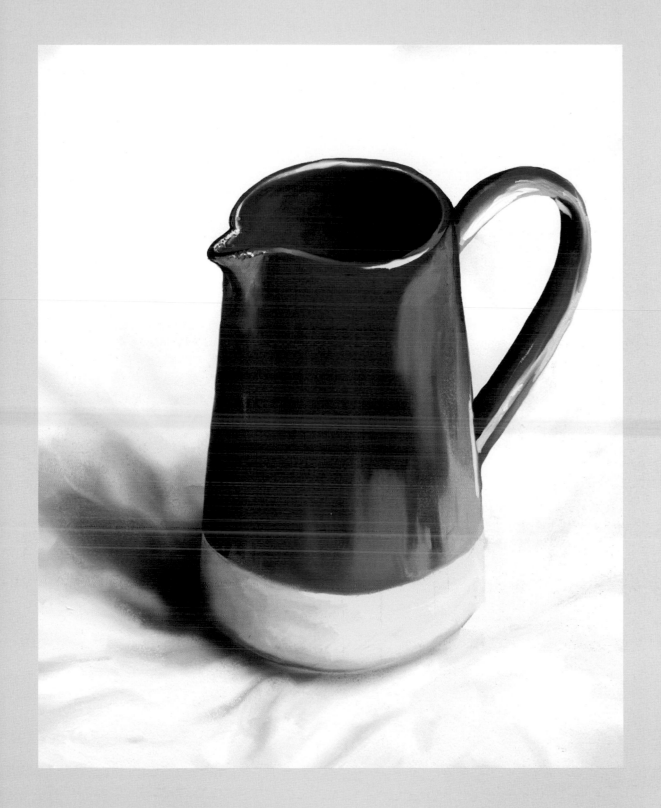

PORTRAITURE

Depictions of the human form stretch back to cave paintings. Depictions of individuals, however, awaited the rise of civilizations. Museums are full of paintings of rich or powerful people from history, and fascination with the face and portraiture in painting continues unabated, even with the advent of new technology such as the camera and latterly the ubiquitous social media selfie.

Portraiture aims to present a sense of who the person actually is, as well as their appearance. This can be done with a careful choice of objects to be included, a particular setting, the atmosphere that is captured, or even the kind of paint technique used. Selfies, I would argue, generally try to make the person featured into something that they are not. As I suspect Susan Sontag would agree, the camera always lies.

Something different happens with artists who paint and draw however; as if a deeper truth can be uncovered through the transformation of a subject into pigment.

The projects in this section introduce techniques to get you started in portraiture, including drawing facial structures and painting skin tones. When you have completed them, I challenge you to sit in front of a mirror for a few hours, and make a from-life self-portrait.

On the iPad, artists can use rich, flowing paints. iPad artist Susan Murtaugh made this work in both Brushes and then SketchBook, intentionally leaving much of it unfinished. You can see the texture of the brushstroke she used, and by cropping the image and featuring the hands, she has made a dynamic composition. Her skin tone palette is rich, ranging from very dark brown to white.

MASTERWORKS

→ In the oil paintings of Claerwen James, her juxtaposition of painterly realism and flat, pasted patterns speaks a truth about our experience of memory, and evokes an atmosphere of both presence and absence.

She uses an abbreviated technique in her brushstrokes, which use a minimum of painterly information for maximum expression. Although rendered in traditional oil paints with a close-hued palette, her paintings speak the language of digital painting, with more abrupt transitions between different tones, and her focus on a single "selfie," out of context, makes it impossible to pin into time.

→ Martin Field used Procreate to draw this self-portrait using thin pencil lines of color. This raw style has captured something deeper than surface appearance—mood, atmosphere, and a sense that the face can also see us.

He explained that the painting was "initially done on three layers and a colored background . . . with a semi-transparent brush tool. The top layer has very little on it, just the glasses and reflections, which I moved slightly as the glasses seemed to slip down my nose during drawing. I duplicated the drawing and modified some of the harshest transitions with another glaze layer."

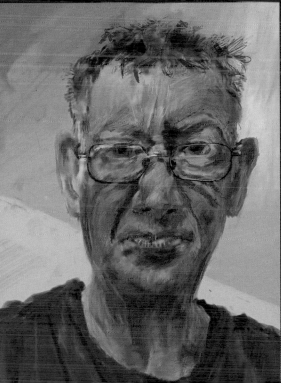

EYE EYE

Let's focus on a simple way to draw an eye, using some of the great tools available in iPad apps. You could stand in front of a mirror and try this, or use a selfie.

1 This project uses Pen & Ink. Select the *Pencil tool* and draw the outline of the eye, eyelid, and eyebrow.

2 Switch to the *Wide Ink Brush*, and place a black dot in the eye. Use the *Eraser* to remove the top of the circle.

3 Adjust the *Eraser* to a very transparent setting, and draw a donut shape on the black iris.

4 Use the *Thin Ink Brush* to pop a black circle in the middle.

5 With the *Pencil* on a fine, thin setting, draw iris details (radiating texture lines).

6 Then use the *Eraser* on a small, transparent setting to add lines of erased white around the iris.

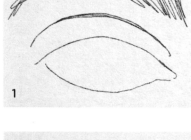

1

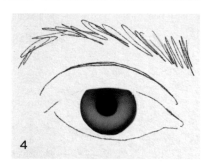

4

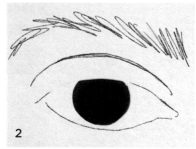

2

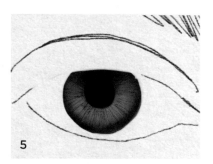

5

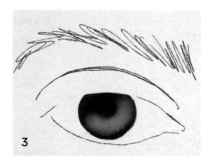

3

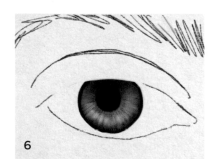

6

7 Set the *Eraser* to very small, on full strength. Dab a few pure-white highlights on the top of the iris. You could reshape the outer edge at this point, too.

8 Select a mid-translucent gray in the *Spray Paint tool* for the shadowed areas: on the eyelid fold, under the eyebrow, underneath the bottom eyelashes, and near the nose bridge. Add some to the outer edges of the white eyeball because they are in shadow too. Touch the shadow lightly with the *Smudge tool* for smoothness.

9 Switch back to the *Pencil*, and begin the eyelashes. Note how they clump together in triangular shapes. Use a thin setting, and go over the same areas repeatedly to create thick lashes—thicker on top than on the bottom. Be sure to make the direction of the lashes change as you move from the outer edge to the center, to the inner eye. Add smaller hairs to the eyebrow.

10 Erase some of the shadow on the top of the eyelid and underneath the bottom eyelashes, where the skin curves around the eyeball. Between the bottom of the eye and the eyelashes there is a strip of pale skin and a thin eraser line works well to depict this.

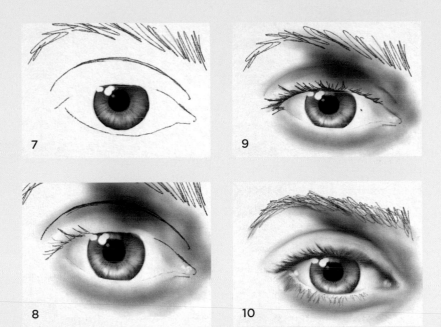

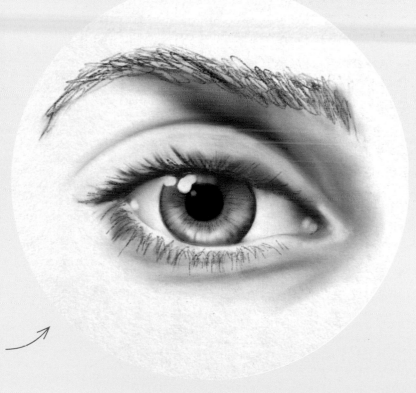

FINISHED ARTWORK
Finally, add highlights to the watery interior corner of the eye near the nose and to the skin around it.

SWIPE RIGHT

Self-portraiture developed quite recently in terms of art history, notably with Rembrandt's famous paintings. Today, the "selfie" is ubiquitous. Why not make a better impression and turn a selfie into an artistic drawing? This quick and easy project uses several very useful tools available to iPad artists.

1 The first step is to take a selfie with your iPad camera and import it into your chosen app. I have used Procreate, which has an "imported image" layer; most apps will allow you to do this.

2 Next, select the layer above and a *Pencil tool*. Start to draw around the major contours of the face, hair, and upper shoulders.

3 It will look something like this, if you turn off the photograph layer. I used the *HB Pencil tool* for the features because they are more delicate.

4 Select the *6B Pencil tool*. Make sure the photograph layer is visible underneath your sketch. Push and hold your finger or pencil over an area of the face. The app takes a sample of the color and loads it onto whichever drawing tool you are using.

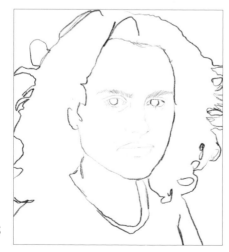

1

2

3

> ### TIP
> Create your own skin tone palette—click on the top-right color circle, then on the "palette" name. Create and name your new palette; add colors by tapping an empty box at the bottom while a skin tone is loaded onto your pencil.

4

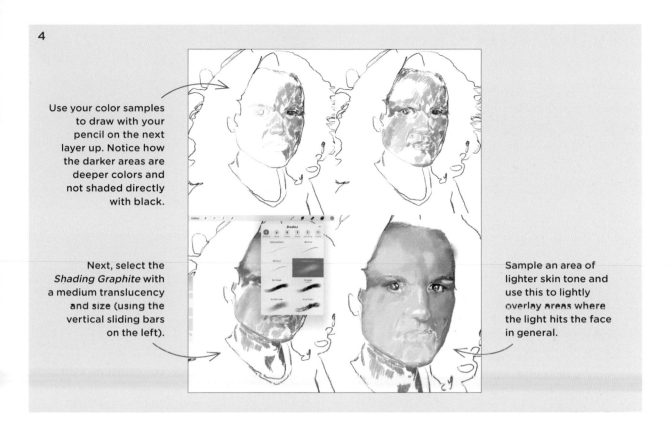

Use your color samples to draw with your pencil on the next layer up. Notice how the darker areas are deeper colors and not shaded directly with black.

Next, select the *Shading Graphite* with a medium translucency and size (using the vertical sliding bars on the left).

Sample an area of lighter skin tone and use this to lightly overlay areas where the light hits the face in general.

5 The small flecks of gray you see here on the face are gaps in my pencil marks, because my background is translucent.

The colors around your skin tones affect them. Try changing your background colors to experiment. Greens, blues, and grays—cool colors—can enhance the warm yellows, browns, and oranges of skin tones.

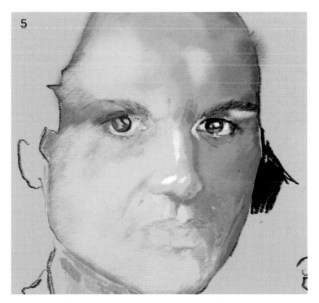

SWIPE RIGHT

6 We are creating a really interesting texture while
 we are modeling the forms here; I love how much
 of the pencil strokes are still visible.

7 Let your pencil strokes follow the way the hair lies.

8 Even "brown" hair is made of a multiplicity
 of color.

9 I chose a pale green for the background in the end.
 The T-shirt has areas of light and shade, too. The
 strongest highlight is on the nose, and the darkest
 area is in the hair.

 Using the *Smudge tool*, you can make areas on the
 sides of the neck out of focus, so the face area seems
 sharper and in focus.

 The areas of the hair that are in light benefit from
 individual pencil strokes describing the direction
 of the curl, with a highlight color for a much more
 realistic effect. Some recessive areas can be solid
 blocks of color however, and this line modulation
 creates depth.

6

7

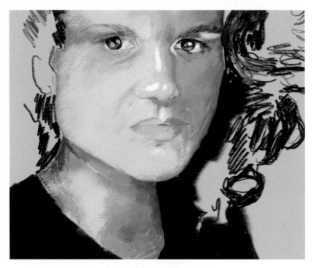

8

FINISHED ARTWORK
I think this is a much more interesting profile
picture than a mere selfie. The pencil strokes
in this portrait create amazing textural details.

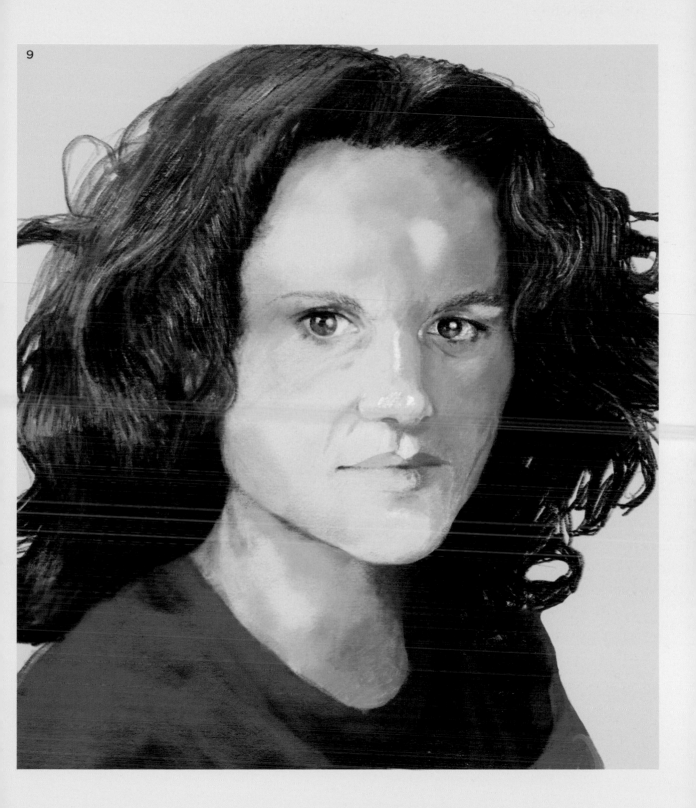

BLACK & WHITE

Portraits can be created with just two colored pencils. In this project, you will use just white and black graphite, which makes it easy to capture quick likenesses. For this, I recommend using Pen & Ink, owing to its terrific smudging tool. If you can't set up a mirror to look into, take a photo, but do use it as a reference only. Although the iPad lets you draw over a photo, the only way to learn life drawing is to . . . draw from life!

Start with a standard screen-sized paper (try one of the watercolor paper textures), and select a neutral tone of brown or gray for the background color, according to your preference.

Before you begin, here are some important things to know about faces:

• Eyes are roughly halfway down the skull.

• They have approximately one eye's width between them.

• If your subject tilts their head, then the features lie on a diagonal horizontal, and one might be smaller.

• The mouth ends around the middle of the iris, if you imagine a vertical line between the two.

• The nose from between the eyes to the tip is about the same length as from one iris to the next.

• The top of the ears are on the same horizontal line as the eyebrows.

• Pay close to attention to where the neck exits from the jawline—a rookie mistake is to make the neck too thin.

• The mouth sits on the same horizontal line as where the jawbone begins to curve upward toward the ear.

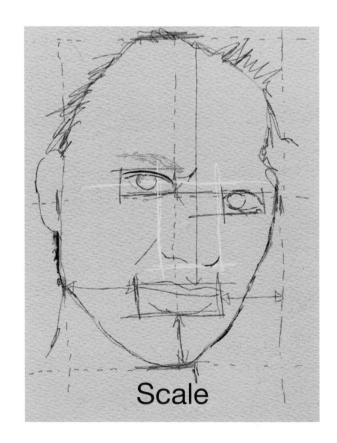

Scale

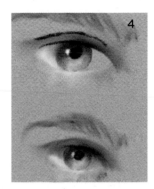

1 Start by making a simple contour drawing in *Pencil*. Decide where the top and bottom of the head will be. Start with the eyes, measuring so there's one eye width between them. Check how many times an eye fits into the space from the hairline around the ear to the nose, to help get the proportion right. Ignore details at this point—just spend time slowly drawing the basic contours.

2 Using simple, short strokes, fill in the dark shadowed areas of the eyes and the hair. With hair, make the pencil lines directional—that is, following the curves and directions of the hairs.

3 The *Smudge tool* will turn lines into value. The white-tipped one is an eraser, and you can change the density of how much it erases; there is also a kneaded eraser, that is a less precise eraser.

4 Apply graphite lines into areas of shading, then use the *Smudge tool* to turn it into pure value. Color in the iris with a *Pencil*, and use the white *Eraser* on a medium translucent setting to create the illusion of light hitting the iris. Add a shiny highlight by using a strong eraser in a small size. Leave the pupil black.

Change to a white *Graphite* on the *Pencil tool* for the eyeball and the highlight on the bottom edge of the eye socket. Remember the white eyeball itself will need shading to push that top eyelid forward. Don't color the whole thing bright white! Just a touch of white will look much more natural.

5 After adding lines of shading in the hair, around the lips, and some of the laughter lines, use the *Smudge tool* to smooth them out. Add white to highlight the underside of the nose, and keep adding darks to the darkest areas, such as the hair.

BLACK & WHITE

6

6 I've worked on the darkness of the hair through repeated overdrawing with *Pencil*. I put crosshatch marks on the right of the face where the shadow falls and then smudged them into smoothness. I also added frown lines and extra definition to the eye on the right.

7 I added some careful shadows to shape the eye socket on the right, and underneath the tip of the nose. The lightest touches carry great power in drawings.

8 It is important to remember that eyes are globes set within bony sockets. Careful modeling of the areas that are in light and shadow means you don't have to use lines to create the form—in fact, outlining all the shapes can flatten them.

9 I crosshatched some white *Graphite* for the nose highlights, and then smudged them.

10 The addition of some shadows on the left side of the neck completes this life drawing.

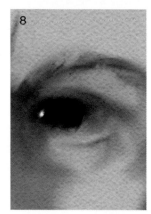

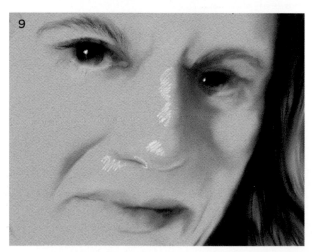

FINISHED ARTWORK
The monochromatic palette in this portrait creates a sense of atmosphere.

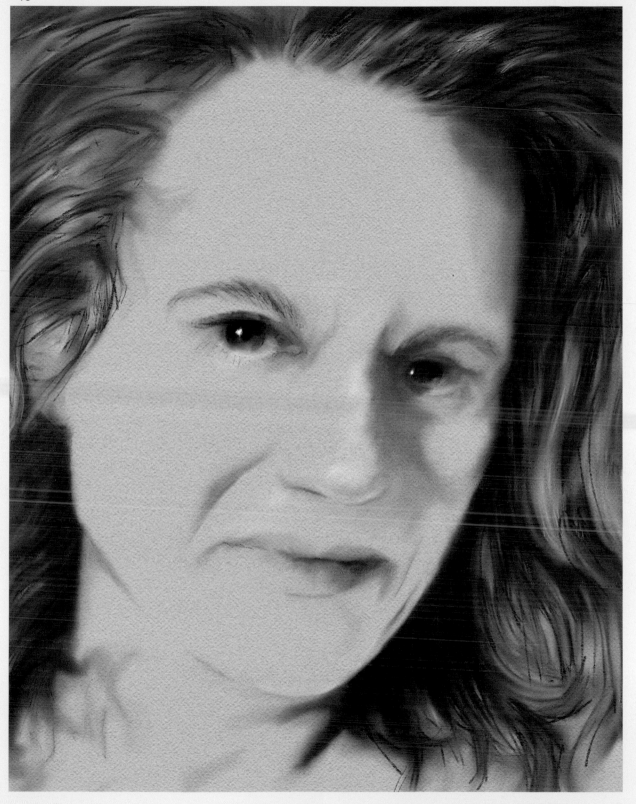

PET PORTRAITURE

Depictions of animals are among the earliest paintings humans ever made, the oldest dating back over 40,000 years. Depictions of bison, horses, aurochs, and deer appear frequently, painted with soot and pigment dug from the earth. This fascination with animals continued as civilizations emerged; the Romans, for example, had mosaic floors showing lions and hunting dogs. Millenia later, artists are still inspired by animals, from Albrecht Dürer's famous woodcut of a rhinoceros in 1515, through George Stubbs's racehorses in the 18th century, to Damian Hirst's sheep and sharks preserved in formaldehyde at the close of the 20th century.

Today, we live closely with many kinds of animals, particularly cats and dogs. It is natural we want to draw and paint them, but pets can be difficult to make stand still for any length of time, so making lots of fast, quick sketches can be a useful way to start to understand the form of the animal.

It can be fun using different approaches to express the characteristics of a pet, too. The cat in this chapter is realistically rendered, built in layers with areas of sharp focus as well as indistinctness to create form. The puppy on the other hand is cut from fun, flat patterns, almost toylike, with his floppy ears and big paws. Two different techniques, but two equally revealing portraits of pets. After trying these projects, try drawing your own pets or animals you see around you.

MASTERWORKS

→ Gwen John (1876–1939) was a Welsh artist renowned for her portraits and room interiors in harmonious close-toned palettes. She also made beautiful studies of her cat. Drawing with delicate forms and lines, and with her sensitive use of washes of light tints, she was able to capture something of the movement and personality of the cat, as well as convey a sense of the artist's own quiet concentration.

In this sketch, she used a lively mix of watercolor and pencil. Many of her initial pencil marks are still visible even though they were layered over. These searching and organizational lines add to the pleasing aesthetics of the piece, as well as help the artist to progress the work. We will use this technique in the "Hello Kitty" project.

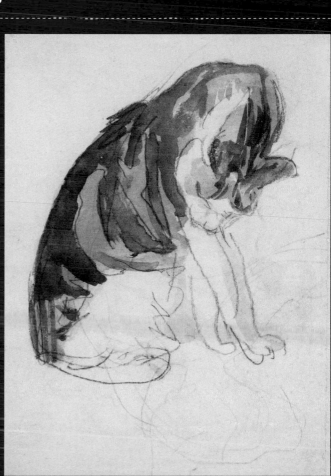

HELLO KITTY

Meet Finn. Finn is a magnificent Maine Coon cat; a breed noted for their exuberant manes, oversized ears and feet, and commanding personalities. Finn lives in Surrey, with his humans, who are my brother and his family. I couldn't resist the challenge of drawing his fur, and capturing his expressive eyes!

Here I have used Procreate and set up my page in portrait (vertical) orientation. I used a printed-out photograph as a reference.

1 Create several empty layers, and select a middle layer to start from—leave a few empty layers above and below. Select the *6B Pencil*.

2 First, set the scale—this means how big or small the cat will be on the page. Too small and you'll struggle with details, too large and you'll crop bits of his body off, probably his paws. Draw guide marks for the top of his head and the bottom of his paws.

To work out how big his head is in relation to his overall size, use your stylus as a makeshift ruler: align the end of the stylus with the top of the head, and put your thumbnail at the bottom of the head. Keep your thumb in position and move the stylus down the body, counting how many times it fits in. My cat's head fits three and a half times. Mark the bottom of the chin. This observational measuring system is called "sighting."

Draw the oval shape of the head, making sure it has the right width to-height ratio, and roughly position the ears. I filled the body with purple for illustration purposes.

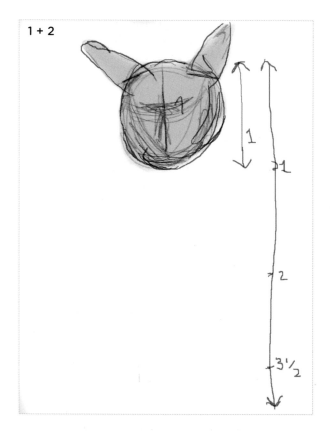

3 There is lots to measure: the length of the paws up the center of the body; how wide he is compared to his height; the size of his eyes; how far they are from the edge of the head; how wide each one is; and how much of a gap there is between them. Make marks each time, including for the inner and outer edges of the paws. Define the ears somewhat, and the pointy bits at the end of the fur.

4 When you have a sketchy rendition of the cat, select a higher layer and make a contour (outline) drawing, using your sketch on the layer beneath as guidance. Draw the shape of the eyes within the positional marks you made, and the tip of the nose and mouth. Go over the shape of the ears, the chin, and the edges of the paws.

5 Click on the lower layer, and delete the sketch lines. I have kept some that are still useful, for now. Your cat should look something like this.

6 Before you begin adding paint, fill in the cat with a dark purple color on the lower layer: it won't show in the final work, but it will make the fur more realistic.

Then, select or create another layer on top of your outline drawing, and start laying in the orange fur, using the *Wet Brush tool*, set to a large size. Next, select a grayish white (not a brilliant white, that comes later), set to a slight translucence. Fill in the white areas, making sure your brushstrokes follow the direction of the fur. Here, you will really see the nuanced, shadow effect that purple has on the white without you having to mark all those details yourself. It's a great cheat.

The *Wet Brush* tapers at the beginning and end, mimicking fur: Procreate and the Apple Pencil are both sensitive to pressure, so pressing harder makes the paint thicker and wider.

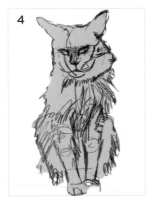

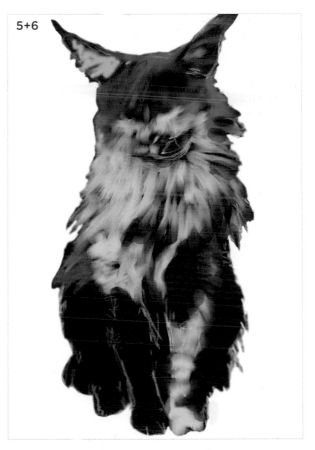

HELLO KITTY

7 Work from large brushstrokes through to smaller ones for the details, layering over the top of your previous paint strokes.

With your *Eraser tool*, you can draw subtractively to cut shape into your edges. You can use this stage to correct any proportional issues.

I have marked the eyes, but not yet tackled the iris or pupils. Your cat should be looking more solid, and roughly all in place.

8 Set a mid-purple as your background layer. Since purple is the complementary to orange it "pushes" the cat forward.

9 Now, let's talk about the eyes. To get the sense of depth on the iris, simply use two values of the same hue (color)—choose a brighter yellow for the highlighted area at the bottom of the iris, and darken the same hue for the upper part of the iris that is in shadow.

The cat's eye is already outlined, so choose the *Pencil tool* again, and carefully sketch the contour. Speed is not your friend in a sustained drawing like this. Take your time, and really observe the details carefully.

10 Put in some pink in the ears. There are a myriad of colors there, either in the smooth areas of skin or fur, which can be rendered in overlaid pencil strokes. Add tonal differences in the orange fur, such as the stripes between the eyes.

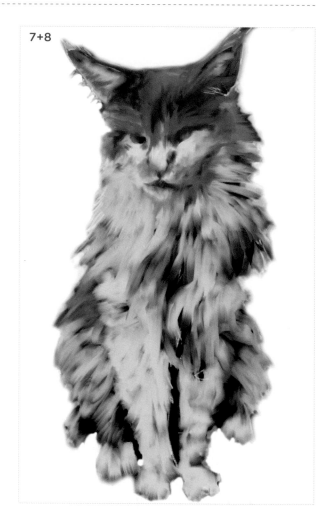

7+8

10

9

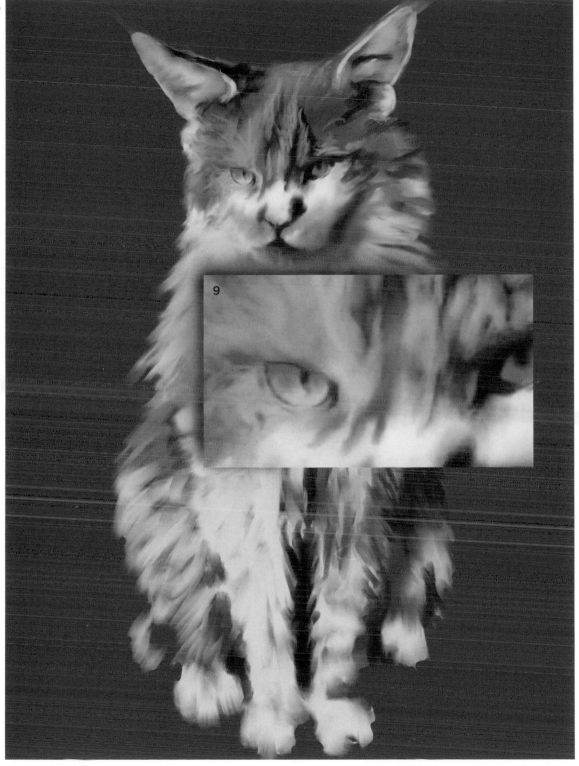

HELLO KITTY

11 For the whiskers, your brush must be very small and have an opacity of around 50%—make them with a single gesture, taking advantage of the taper at the beginning and end of the brushstroke.

12 It's finally time to switch from the gray-toned white to the very purest white, and apply it to the highlight areas: on the left of the chest and leg, on the right of the chin area, and also on the cheeks, under the eyes.

Note that we used just a dark purple background, gray-white, and a bright white to create these myriad tones.

The areas with sharp detail and brightness come forward, and the dark, less defined areas, like the back legs, seem to fade backward. This helps our cat have a realistic form.

Hello kitty!

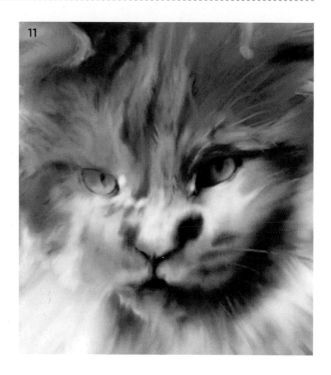

FINISHED ARTWORK
The cat comes to life! Texture is incredibly important in pet portraiture.

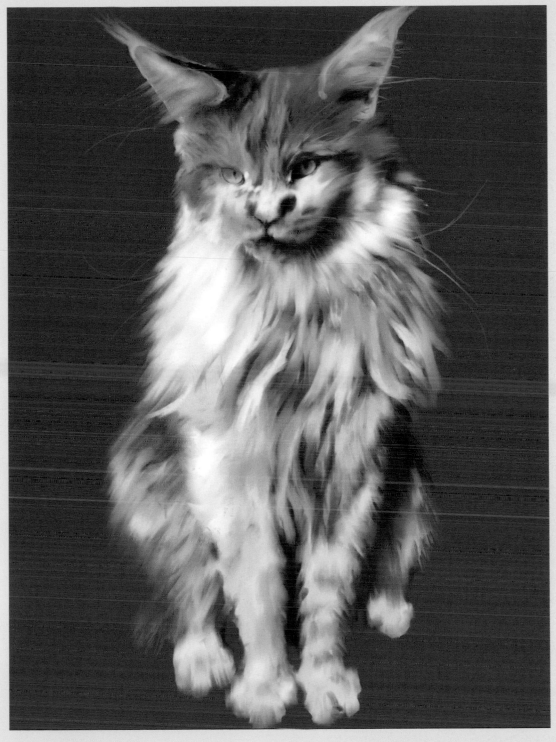

PUPPY LOVE

Let's have some fun with patterns! This puppy was created with Tayasui Sketches Pro (version 2), which lets us play with patterned paper and text. You will be creating the portrait with patterned shapes; base these shapes on your own little friend—I based this on a beagle puppy.

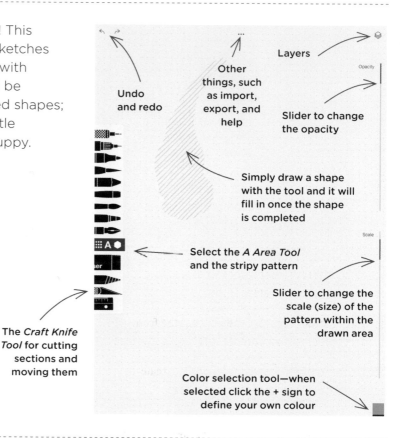

Undo and redo

Other things, such as import, export, and help

Layers

Opacity

Slider to change the opacity

Simply draw a shape with the tool and it will fill in once the shape is completed

Select the *A Area Tool* and the stripy pattern

Scale

Slider to change the scale (size) of the pattern within the drawn area

The *Craft Knife Tool* for cutting sections and moving them

Color selection tool—when selected click the + sign to define your own colour

1 Select the "A" *Area Fill tool*, and the pattern sub-menu. When you draw a shape, the pattern fills in when the two ends meet. Change the opacity and the scale (size) of the pattern within the shape using the two sliding bars on the right of the screen.

2 Choose a pale background color, and if you like, add a pattern, too. I chose faint dots. On the layer above, draw the ears, nose, and jaw.

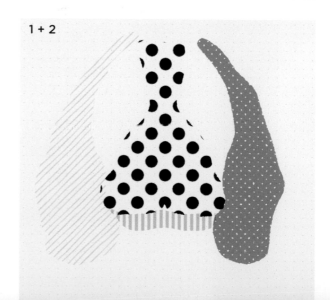

1 + 2

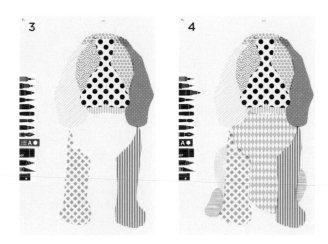

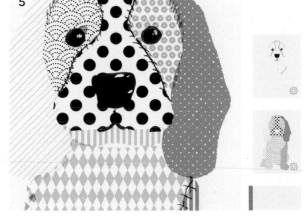

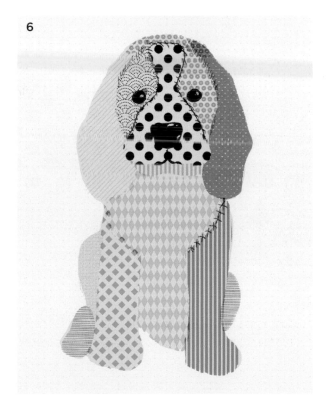

3 Fill in the eye areas, the top of the head, and the
 two little paws in front.

4 Add in hind paws on the outside of the front paws,
 plus a blue diamond pattern for the body.

5 On a new layer, use the *Brush tool* to create two
 translucent black dots for eyes, and the *Eraser*
 to add a "shine."

 Draw a nose, with a shine, and a smiley mouth.
 Use a *Pen tool* to add "stitches," as if the puppy
 were a stuffed patchwork toy.

6 To help the patterns gain visibility against the
 background, I decided to add a translucent gray
 on a lower layer, in the shape of the complete body.
 Using the *Knife tool*, I cut the gray from the chest
 and nose areas, so these would remain cream,
 as if in the light.

PUPPY LOVE

7 Let's give him a collar: use the *Fill Shape tool* and
 a color (I chose black). Add details like a shiny
 edge, or a connecting loop.

8 Use the *Text tool* to write the name; in this case
 "Fred."

9 Have fun adding details, like these dark gray
 patches on the hind legs, held on with "stitches."
 I also added outlines to the toes. Don't forget
 the tongue!

10 For finishing touches, I created extra colored
 patches above the eyes, layered different patterns
 onto the ears, and added patches of pinks, oranges,
 and greens to the legs. Finally, I made a mat on a
 lower layer for Fred to sit on.

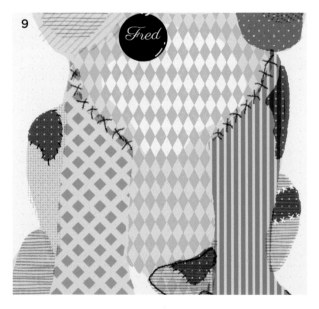

FINISHED ARTWORK
**Choosing and arranging the patterns
and colors in this drawing was so much fun.**

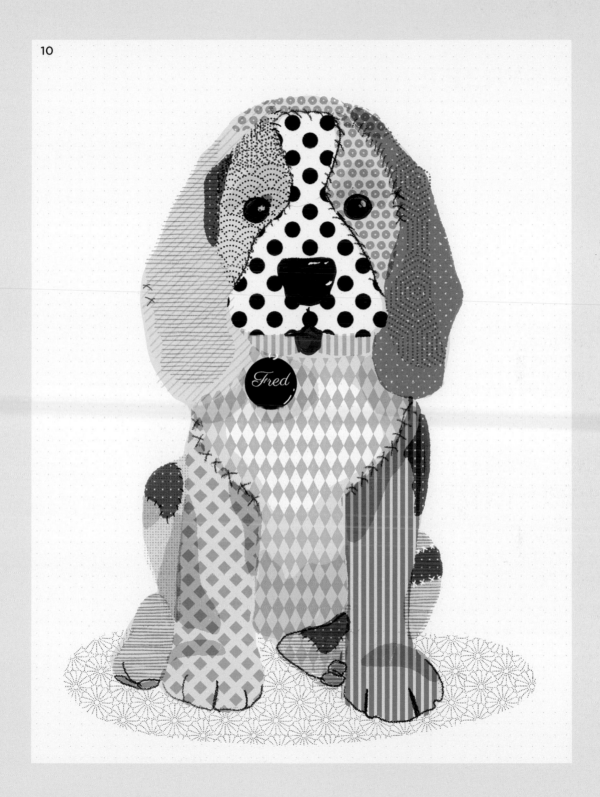

STREET ART

There are examples of graffiti—illicit texts or images in public places—that date back to ancient Egypt, Greece, and Rome. It often expressed underlying social and political tensions, and mainly took the form of written statements. It continued as a protest form through the intervening centuries, and in the early 1980s, with the development of paint in spray cans, pictorial "street art" emerged.

Artists such as John Fekner, Keith Haring, and Jean-Michel Basquiat became recognized and valued by the art establishment, even though their works were created on private property, and, thus, were mainly illegal.

Making street art on private or public property remains a crime, of course; but don't worry, because in the project in this chapter we will simply augment reality, and so we will remain quite safe!

Take your own photograph for this project, and bring your own environment into the artwork. Once you have learned the principle of how to draw and paint on photographs, there are no limits to ways you could augment your own reality.

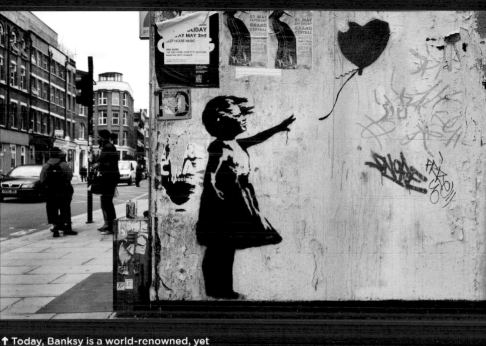

↑ Today, Banksy is a world-renowned, yet anonymous, artist who creates his works on the streets, using stencils and spray paint. His work is humorous by juxtaposing opposites, such as bombs and flowers, and highlights points of social unease or problems, just as graffiti artists did in ancient Rome.

WHAT WOULD BANKSY DO?

My studio is in an area of downtown Dallas called Deep Ellum. Noted for its history with music, particularly blues and jazz, to this day it remains an eclectic mixture of the arts, music, and commerce, with historic, crumbling buildings and many dubious alleyways. Recently there was a project to create forty murals on the walls of Deep Ellum by local artists, and as I watched them appear, I wondered what Banksy would do if he visited Dallas. Given that Dallas was built on oil, I chose this as my theme and to incorporate some of Banksy's most common motifs: flowers and small children.

1 The first step is to take a photograph of a wall. I found a colorful mural on a wall near my studio. It is on a corner, and right next to it I could see the full depth of a long alley, which made a dynamic composition.

2 I decided to use the free app Art Studio for iPad, because it has a nice and easy-to-use *Spray Can tool*. Import your photograph into the app, and, if necessary, remove the existing mural, something that Banksy, allegedly, is also wont to do. Use the *Color Picker tool* (the icon is a small dropper), press it onto the wall's background, and the color will load onto your brush. Use the *Spray Can tool* at 70% opacity and spray over the mural until it is gone.

1

2

3 Create four new layers above your photograph layer, and click on a middle one. Select the *Spray Can Brush* and set the size to around 50% and the opacity to around 60%. Spray black paint over the area of the wall where your image will sit. I have sprayed a rough approximation of a nodding donkey (an oil extraction tower), and painted oil spilling at an angle onto the ground.

4 Next, select the *Eraser tool* and "draw" with the eraser to remove the areas of black you don't want, the negative space. This is subtractive drawing— Banksy cuts a stencil out of plastic or paper and then sprays over it, creating the positive image, or the image he wants to see (additive drawing).

Make your eraser smaller for the detail areas, and zoom in on your photograph to make it easier.

3

4

4

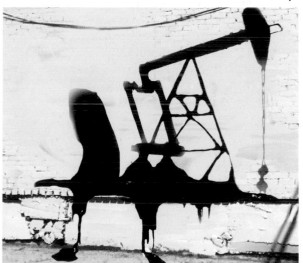

WHAT WOULD BANKSY DO?

5 When that is complete, select another one of the
 blank layers, and carry out the same process for
 the little girl. Start with the outside of her body,
 and then zoom in to erase the spaces between her
 lower legs and shoes, elbow, and her hair.

6 Now onto the flowers. Art Studio has a brush tool
 that resembles flower heads, and so I chose to use
 it here in a variety of colors and sizes. (Of course,
 you can draw the flowers in different ways). Go to
 the paintbrush icon, and click on the pulldown
 menu "Selected for Current Tool." Under the
 "assorted" brush shape, find number 220, which
 has a nice star shape.

 On an empty layer, dot a couple of flowers on your
 drawing; vary the color and size. Use the *Crayon
 tool* for the green stalks.

7 And that is it! As you travel around, whether on
 your commute, or vacation, or on a night out, start
 looking around you at the walls and the edges of
 your urban environment with the eyes of an artist,
 and ask yourself, what would Banksy do?

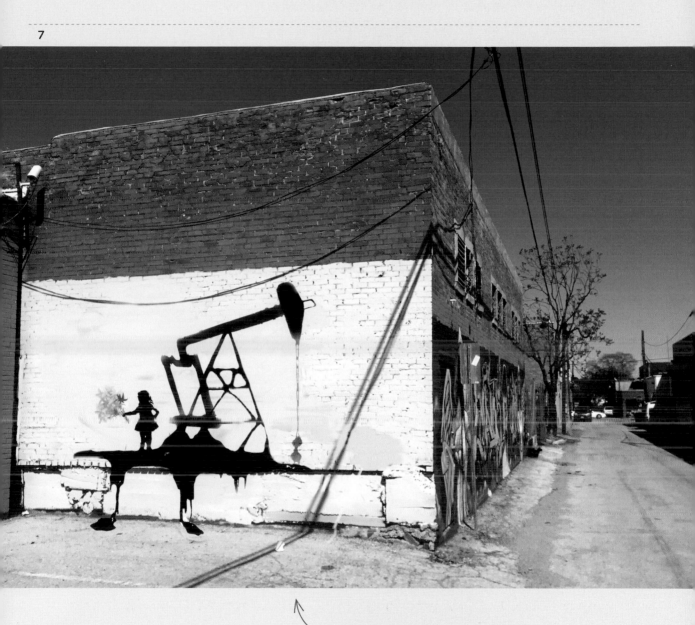

FINISHED ARTWORK
Legal street art that pays homage
to Banksy and Deep Ellum's roots.

BEAUTIFUL CHAOS: MONET'S WATER LILIES

There are few things in life as relaxing as a walk in nature. As our lives become increasingly urban, time spent in wilderness, parks, or gardens is correspondingly more valuable. Once one of the dominant forms of art, landscape painting is no longer at the forefront of the art world, but it remains one of the world's most popular pastimes.

The definition of landscape painting is rather narrow: "open vistas" of "countryside." Today, exploring nature as a genre has been broadened to encompass ideas about the environment rather than simply "landscapes." Artists are bringing novel approaches in new media to works of this nature, such as making sculptural art that exists in the countryside itself, from natural materials such as stones, sand, or logs, rather than simply making a painting of it.

In my own work, I make paintings with concrete and these arise out of considering the landscape. In Dallas, where I now live, there is a lot more concrete than there is grass, and my work is part of a discussion in our culture about how we balance the human need with the natural.

Whatever the medium, landscape art, like all art, needs to arise from the experience of the individual, so be sure to take your iPad with you on your next excursion! It is a great excuse to sit under a tree somewhere, and take a break from our busy lives.

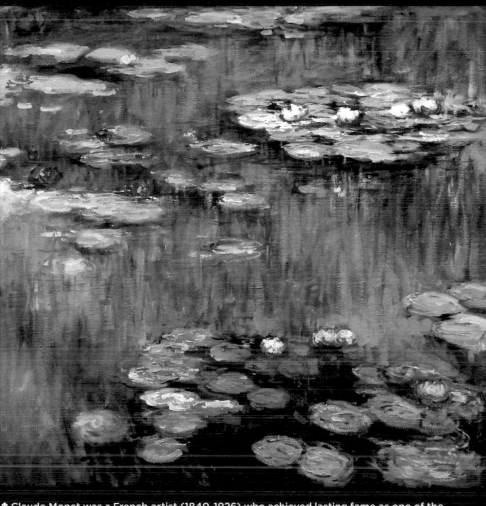

↑ Claude Monet was a French artist (1840-1926) who achieved lasting fame as one of the Impressionists. Technological developments such as portable tubes of paint and folding easels had enabled artists to leave their studios and paint on site (en plein aire) for the first time. Whereas studio lighting was artificial and controllable, the atmosphere outdoors was mutable and affected the way things could be seen. Monet was committed to this accurate, naturalistic depiction of light, and his interest lay with this analysis rather than social commentary or interpretation. As Cezanne wrote, "He was only an eye, but what an eye!"

The painting we will be using as our inspiration for this project establishes a contemplative mood through chromatic harmony, and form through complementaries. The majority of the painting is blue and green, which are analogous and harmonious, and a small number of the the lily pads are painted in warm red and pink tones, the complementaries of these green-blue hues, causing them to stand out and act as focal points. In fact, the only real use of spacial techniques is the fact that the lily pads get increasingly small towards the top (or the back) of the scene. The Nymphéas remain one of the world's most beloved painting series, and this project is a homage to the genius of Monet.

MONET'S WATER LILLIES

The secret to this artwork is to recognize that it is a balance of organized chaos. Essentially it is a very simple technique: we will make lots of short marks, building up the surface layer by layer, just as Monet did with his oil paints. We don't need to make an exact copy here, so enjoy the process and let it be your own version.

1 In Procreate, create a new square canvas. Choose the *Oil Pastel* tool in the Drawing menu, set to a medium size and full opacity. Click on the *Oil Pastel* icon in the pull-down menu, and make sure the settings for *Glazing* and *Accumulative* are activated.

2 On the first layer, start with a rich middle-value green, and begin covering the canvas with short vertical strokes. Don't worry about completely covering the white of the canvas - we will continue layering until this is achieved. Vary your greens in places, especially with darker greens at the very top and the bottom of the canvas.

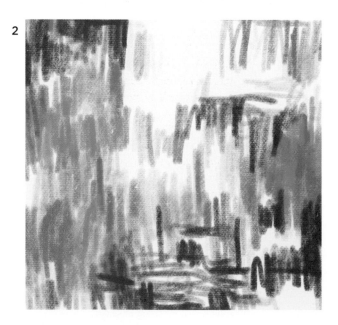

3

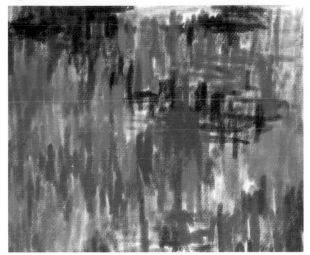

3

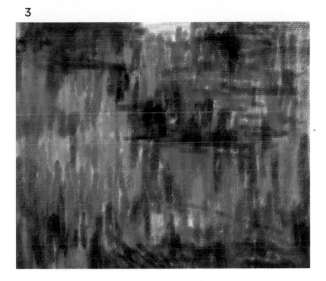

3 On the next layer, choose a light value mid-blue color, and do the same again, drawing over the top of the green if necessary. These blue ones are longer and thicker around the middle of the canvas, and are shorter at the top. In places, they coalesce together into pools of blue shapes, as they are reflections on the water.

4

4 On the next new layer, select a much darker blue color for the horizontal strokes that occupy the areas underneath the patches of lily pads, at the bottom right, top right, and top left.

5

5 Now, we are going to get a little technical with this oil pastel tool. Click on the tool icon again, and increase the *Jitter* and the *Grain Behavior* percentage, which will make it rougher and more like the texture of Monet's oil paints. If you ever get in a muddle, click the button to put it back to the original state. Each of the tools in fact can be changed in this way, and as you will notice along the bottom of the pull-down menu there are options to change everything from the profile of the brush to the scatter of the pixels. It can be a lot of fun exploring all the ways these can be amended, and I encourage you to do this!

6

6 On the fourth and final layer, we will overlay all the colors we have already used to work towards the visual appearance we are looking for.

MONET'S WATER LILLIES

7 Finally, we get to the fun of the lily pads. Let's go crazy with these beautiful reds, pinks and purples, yellows, which are warm colors that react against the cool background. Be aware of the relative size of the lilies compared to the size of the canvas, and try to scale them appropriately.

Observe how the lilies are arranged in a Z shape, which is a simple, effective path for the eyes to create movement and depth. Crucially, the lily pads get smaller as they get towards the top of the painting, creating a sense of recession - atmospheric perspective again! Be sure that the ellipse, or oval, of the lily pad is wider at the front, and increasingly thin towards the back. Also, the greatest mix of eye-catching warm colors are in the foreground, which draws the eye and make it seem larger in the hierarchy, and so closer to the viewer. Where necessary, remember you can use the Eraser tool to reshape the lilies. I used pink, purple, green, yellow, creamy whites, blue and deep red to make the flowers.

It is very important to activate the whole painting with those especially dazzlingly warm reds, as can be seen in the three or four flowers at the bottom, and two in the middle left. These warm reds pull the whole color scheme into a brighter harmony, and really shows Monet's genius with color.

8 Finally, go back into each layer and reinforce the colors and values there, from the dark green first layer, the purple-blue horizontal lines under the lily pads, to the rich luscious blue paint in the mid-ground. Keep adding, touch-by-touch, and stopping to look at your painting. At some point, you will see that it is done. This free form creation is one of the most compelling things about painting; it's a beautiful, flow-state activity in which to lose yourself.

7
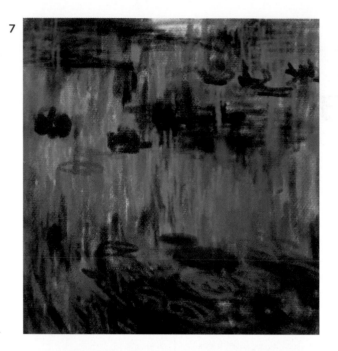

7
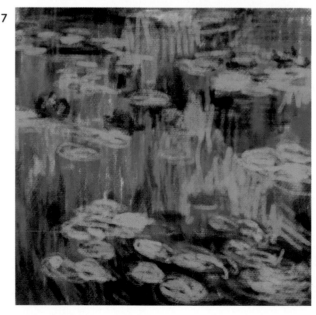

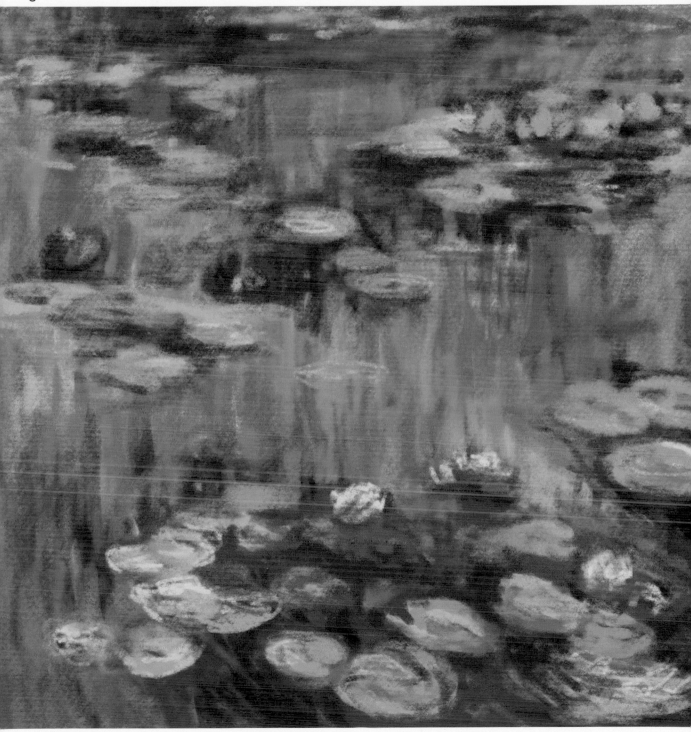

POINTILLISM

Pointillism is a visual illusion made famous by Seurat, in which our brains mix colored dots together to create additional tones optically, rather than them being mixed on the paper by the artist.

This project uses ArtStudio, and the *Dot Brush*.

1 Set your brush to full size and full opacity overall (the bottom-most slider), with less opacity on the left and right edges (the two small sliders above).

Move your stylus around and it will apply a spray of dots; to get a light, smooth, less opaque application, use lighter pressure with your finger or Pencil. Tapping it creates a spray of more opaque dots.

2 Start by making a simple blue sky and a base of brown soil, which meet below the vertical center of the paper.

3 Deepen the sky by layering more blue dots over it, and darken the soil with further brown dots. Then, add purple over the blue sky.

4 Add a rich orange over the brown and overlap the bottom of the sky. Move to a higher layer.

5 Add paler blue at the top of the sky.

6 With a dark green, start to establish the shapes of a row of trees, covering much of the sky, but not touching much of the ground.

7 Add a lighter green and then enrich and darken the green with red. Simply using a dark green would look flat. By using the complementary color to green, you can create vibrant dark depths.

POINTILLISM

8 To simulate light striking the trees from the left, layer darker green on the right sides, and add a smaller purple patch within this. Use light green on the left of the trees.

9 Now, alter the size of the dots. Select a new layer, small size brush, and add four trunks.

10 Add purple over the top, then yellow on the left of the trunks as highlights. Then, use the eraser to cut straight edges.

11 Add purple shadow under the trees on a right diagonal to simulate the direction of light. I added purple to areas of the trunks that would be in darker shade.

12 The final touch is to add light blue over the very tops of the trees, and on the left to separate the tree from the edge of the paper. Brush blue lightly over the brown tones at the bottom for a hazy sense of atmosphere.

FINISHED ARTWORK
An atmospheric woodland with multiple tones created simply with dots!

OCEAN'S EIGHT

I am sure, like many people, you take your iPad with you everywhere you go, including to the beach. I visited Port Aransas on the Gulf Coast of the United States earlier this year, and made this simple, fast study of the waves in eight easy steps.

1 In Procreate (or your app of choice), select the background layer and choose a nice sky blue color.

2 On the layer above, select the *Old Brush tool* (or any "rough" brush will do). In the beach area, drag touches of an orange color—don't cover it completely. Leave touches of the blue background showing through to simulate pools of water.

Then, choose a dark blue-gray, set it to around 50% opacity, and drag the brush roughly over the area occupied by the ocean.

The horizon is higher than the middle of the paper, in the upper quarter. It's never a good idea to divide a landscape drawing exactly in two.

3 Create a new layer. Use the same dark color to create a smoother, darker area on the horizon by using a smaller brush with a higher opacity. I added an "ocean spray" texture over the top of the central ocean area with the *Clay tool* (from the *Organic menu*) in a deep gray-green. Your horizon line doesn't have to be perfectly straight, because you will draw waves over the top later.

4

5 + 6 + 7

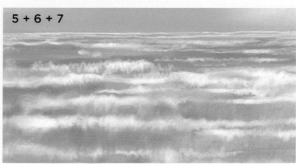

8

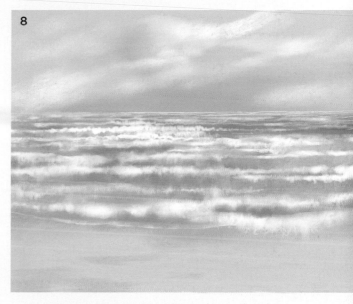

4 Create a new layer, and choose a slightly richer blue than the background one. Apply it along the horizon on the lower sky area—mainly in the middle of the picture. Leave an uneven edge at the top to suggest the bottom edge of the clouds.

5 Start a new layer. Switch to the *6B Pencil tool* and choose a color that is slightly off-white, with just a hint of yellow. Draw horizontal lines—thin, straight, and close together at the horizon. As you move down the page, make the wave lines farther apart, and with more obvious vertical wiggles. Be loose, and have fun.

6 Change the size and opacity of the *Pencil tool* to vary the line quality. Use with the *Airbrush tool* for different texture, or try *Wet Acrylic* and *Fresco* (under the *Artistic menu*).

As a general rule, the waves at the very bottom of the picture will have the most height—except for that final thin line where the wave is pulling back from the beach as the one on top crashes over it.

7 Touch the waves with the *Smudge tool* in places to create a sense of foam and motion.

8 Finally, scrape some translucent white diagonally across the sky, on a wide brush setting.

FINISHED ARTWORK

Put all the layers together and you will have a lovely sketch of the waves rushing to the shore.

OIL LANDSCAPE

This easy landscape project mimics oil paint and uses the same techniques artists' use *en plein air* to create wet-on-wet paintings in oils. It uses ArtRage, because the app offers a brush that applies "wet" paint thickly, which allows you to blend colors into one another.

1 Choose a landscape-orientated canvas (wider than high), and fill it with a dark orange-red. On the layer above, choose the *Square-headed Oil Paint Brush* on full loading and with about 30% thinner, making sure *Insta-Dry* is off. Begin to apply a mid-blue for the sky. Don't try to cover all the background—seeing this color poke through will add "zing" to the painting.

2 Choose pale blue, and go over the top, adding luscious swirls. Add darker gray-blues toward the horizon. The paints will mix together, making new tones as you apply them. Enjoy this! Don't try to over-control it. This is what painters love about oil paints.

3 Now, start to mix in strokes of yellow, green, and orange around the horizon line, which should be in the lower third of the page and not the exact middle. Keep it loose and be open to happy accidents! Take note of the way the brush varies, and how the paints either mix or stay separate. This is such a satisfying feature of ArtRage.

4 Making the brush smaller, add a line of dots and swirls in tones of deep green and dark blue. Make it a varied line, with dips and hills, going up at one side toward the edge of the paper.

5 At night, regular colors are stripped from the spectrum and replaced with gray tones. In West Texas, the landscape that inspired this composition, there are also many blue-green plants and cacti. Fill the rest of the bottom of the painting with strokes of blue and gray—add shrubs for interest. Remember to leave bits of the orange poking through, to really set off the neutral tones.

6 Finally, I added a fence with just thin gray lines.

FINISHED ARTWORK
This kind of painting is so enjoyable on the iPad, and I hope you will stop in front of many beautiful views to make fast "oil studies" for your visual diary.

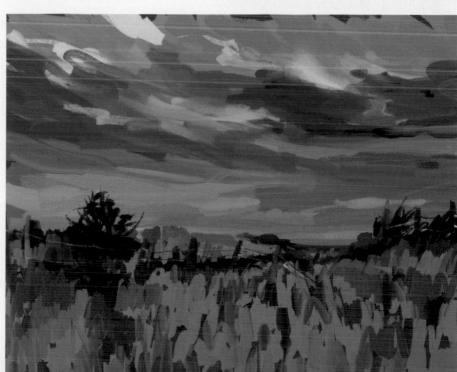

HANAMI & BOKEH

Bokeh is a Japanese term (literally meaning "blur") that describes the quality of the out-of-focus area of a photograph that occurs when we use lenses to focus on a foreground. Good bokeh has a beautiful, soft aesthetic—more than just background blur—and is best created using telephoto or portrait lenses with fast apertures. I became fascinated with this effect during my trip to Tokyo during Hanami, the annual Cherry Blossom festival.

1 In ArtRage, open a new landscape-orientated canvas, and set the background to dark green.

2 Add several new layers for leaves in different sizes. Starting at the bottom layer, add large blobs of translucent greens; on the next, add dots of red and purple.

3 This is how the layers look when separated.

3

1 + 2

4 On the next layer up, add a branch in the top left corner of the canvas. Use a round brush with a mid-brown paint and a gestural stroke. Add blobs of dark red for blossom and green leaf shapes. Add lighter red and green on top to simulate light.

5 In the bottom left corner, on the lower layer, add some dark pink blossom shapes. Dark and light pinks create instant depth and form. Remember to add some stalks.

Then, on the next layer up, draw a brown paint line that arcs from these blossoms into the top right of the page, to form a new branch. I left gaps in the branch where I planned to place blossoms.

6 On the topside of the branch, use the *Spray Paint tool* in *Watercolor mode* to add a lighter brown for directional light. The bottom of the branch remains dark. On top of the light, add touches of dark brown to create a sense of natural pattern. You can use your *Eraser* to reshape it to have the idiosyncrasies of a real branch, and to make a sharp edge. It seems to float; sharp against the out-of-focus background.

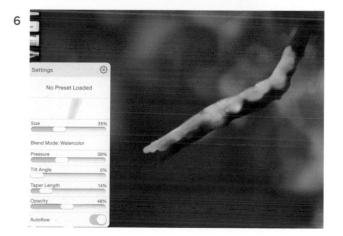

HANAMI & BOKEH

7 Next make a new layer to paint blossoms. These are gradually built up from general shapes to fine details.

Choose the *Round Brush* with a high amount of thinner and a lower loading number. First, paint large pink shapes where you want the blossoms to be, then on top of these add darker pink. Here I am working only on the central blossoms.

Play around with the *Paper Wet*, *Insta-Dry*, and *Auto Clean* settings for different effects.

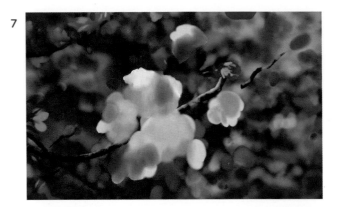

8 Cut new sharp edges using the eraser (you can do this without affecting the background, since the blossom is on its own layer).

Add further dark pinks for shadow, and lighter areas too. Draw fine lines with the *Felt-tip* tool for the stamen, with yellow horizontal shapes for the pollen.

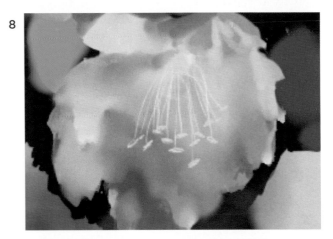

9 Here, I have created "flat" shapes first, with modulated shadow, and added curling petals, shadow, and stamen afterward. The stamen at the bottom have small dots of gray on them.

10 Use the *Felt-tip tool* in a pale pink color to draw the edges of petals and texture lines on the surfaces. The dark pink next to the pale edge makes the pale edge come toward the eye, which adds form.

11 I added a deep almost-gray shade of pink to the top of these flowers, so it appears as though the leaves are casting shadows. This is another way to add depth. The sharp edges were created with the *Eraser,* and I added stamen. Some blossoms are just buds in a deeper pink. Use just one or two tones of pink, in bloblike shapes, to simulate a few wrapped petals.

12 For the stalks, use the felt marker in a deep red. Even here you can add touches of light and dark. The bottom blossom is simply lots of pale pink paint strokes on top of each other, and the petal is delineated by the area of gray-pink shadow. The back of a blossom has a star-shaped section that attaches the stalk.

HANAMI & BOKEH

13 Place your rough leaf shapes in light green, then add darker green for shadow. Cut a more resolved shape out of this with the eraser, and use the *Felt-tip* tool to add yellow-ocher serration lines on the edges, and stalks down the centers. Use pale green for the veins. Finally, add stripes in a deeper green to suggest shadows from branches above.

The leaves you see here demonstrate a progression from simple shapes to built-up details.

14 I added pattern to this leaf using a very *Fine Oil Brush*. On the right side, the green is paler to show the direction the light is striking it. I used a very fine *Eraser* to cut the serrated edges. I also captured the shape of the leaf on the left twisting toward its center at the bottom, first by cutting the shape and secondly by adding edge details across the twisting part. The underneath of the leaf that is revealed is a purer green color.

15 I edged the leaf on the left with pale green, then used the *Smudge tool* to make the back edges slightly out of focus. This will help create the bokeh effect.

16 This is what the layers look like separated. Separating the elements helps to capture the sense of bokeh by allowing for the use of sharp lines and detail in the foreground, and general hazy forms in the mid and background. As well as perspective, this is a powerful way to create depth.

13

14
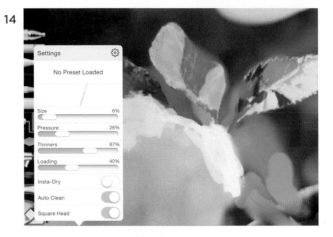

15
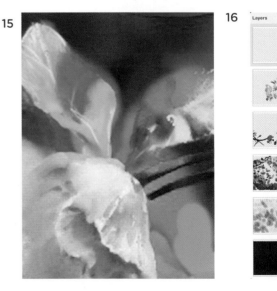

16

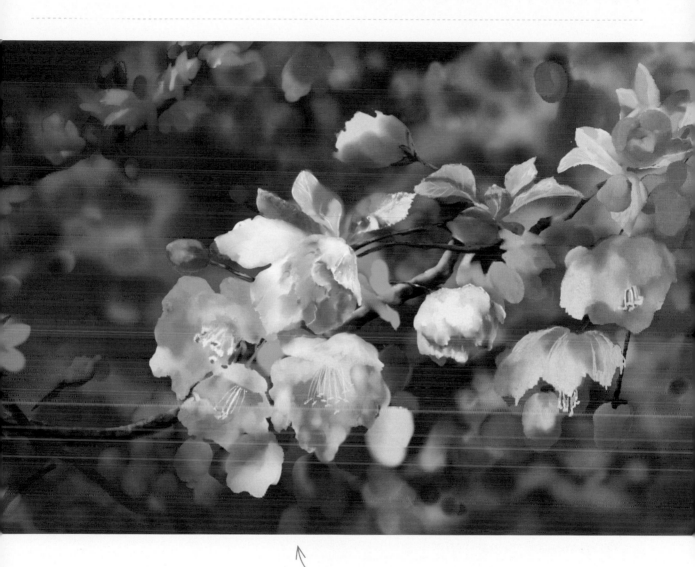

FINISHED ARTWORK

Beautiful blossoms brought into sharp focus thanks
to the effects of bokeh. Layers also allow us to create
a lovely sense of depth.

INTO THE WOODS

Drawing or painting outside (*en plein air*) is a totally different experience to drawing from a photograph. When simply copying a photo, many decisions are already made for you, such as where the edge of the picture plane will be. When sitting in an environment like a forest, your vision is overwhelmed from all sides—light and shadow is ever changing, and color changes as the sun rises and sets. I encourage you to try it with your iPad. Another approach is to take photographs during your walks, and combine the information in the photographs with your real-life experiences.

For this project I used two photographs I took in a forest in Houston, Texas, adding the branches from one to a lichen-laden tree in the other to improve the composition.

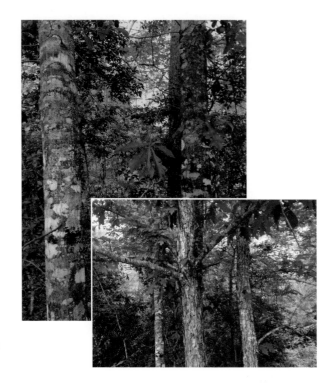

1 In Procreate with a portrait-orientated canvas, set the background to a pale, desaturated green, and use the *Flat Painting Brush* to daub layers of green around the top and sides. Then, blur it using the *Artistic menu's Fresco* setting.

2 On a higher layer, paint four trunks in pale brown, then use the *Burnt Tree tool* in the *Charcoals menu* to dash some highlights on them.

3 On a new layer, draw two thick brown trunks. On the lower layer, put a darker trunk behind, on the right. We have created a background, mid-ground, and foreground, essential in any landscape.

4 Draw five smaller branches at the top of the left tree. I liked these branches, but they also stop the eye from shooting straight up the trunk, and off the canvas; rather, the branch directs the eye to the trees on the right. Then, edge the two front trunks with dark brown.

5 Drop to the lowest layer, and start adding the ground by creating impressions of brown and gold leaves. Use the *Flat Painting Brush* and make short, leaflike strokes. Pressing harder will darken the paint, as will painting over the same place twice.

6 Add darker green and brown touches from the outer edge, moving to the center, to create mid-ground bushes. Make it slope toward the center, and also up to the right-hand side, to create an informal "pathway" for the eye.

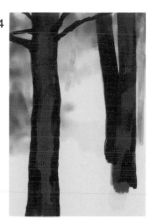

INTO THE WOODS

7 On a new top layer, let's create the foreground. Pick a medium-saturation green and make leaf-sized paint strokes on the right, and add a little to the left tree around the trunk. Create stalks for the two clumps on the tree on the right.

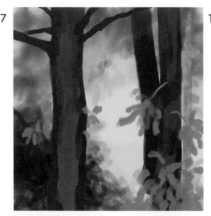

8 Drop to the lower layer. With a very dark green, draw background foliage. The dark green gives a sense of depth.

9 Using a light green, set your paintbrush very thin, and add highlights down one edge of all the leaf shapes, to mimic curling, twisting leaves. Use the *Eraser* to cut hard edges.

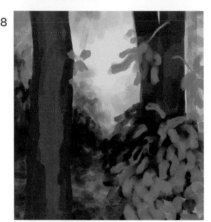

10 With a rich deep green, do the same on the opposite side of each leaf.

11 Using the *Flat Marker*, draw on leaf veins, serrated edges, and other line-based details.

 Sharp details drawn with lines will seem to come toward the viewer; it's called modulation and helps us create form.

14+15

12 The leaves don't have to be perfect; altogether, they have a nice mass foliage effect. Putting excessive detail in a painting will create a hyperrealism that isn't entirely natural. Our eyes don't see all details at once—rather, they filter out a lot of detail and focus on one or two points of interest. By replicating this in our technique, we create a naturalistic effect.

13 Using the *Burnt Tree Charcoal tool*, darken the edges of the front tree, and add textural lines. Also darken the tree at the back, and add dark patterns to the one on the right.

14 Using the *Flat Brush* on a thin setting, with a gray-white paint set to about 70% opacity, draw bark lines around the branches at the top. These should follow the curve of the branch—this is "cross-contour" drawing.

15 Vary the line to create small smudges here and there to simulate light. Work these larger patches of translucent gray-white onto each of the trunks.

INTO THE WOODS

16

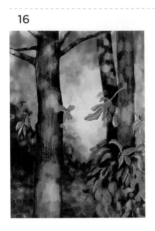

17

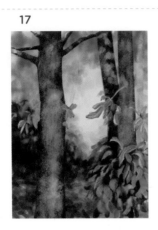

18

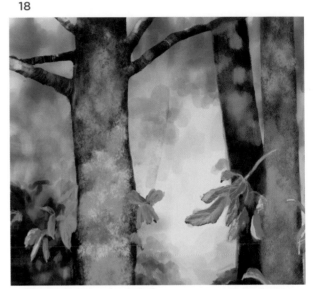

16 Add pale brown vertical lines using the *Burnt Tree Charcoal tool* up and down the trunks, to simulate bark texture. Then, apply a layer of mid-yellow charcoal.

17 Using the same charcoal, add yellow-brown textural marks.

18 Then, add a green lichen texture. Use both a green tinted with white and a darker value. Add ocher-yellow lichen in places, as well as an earth-red pinkish hue.

19

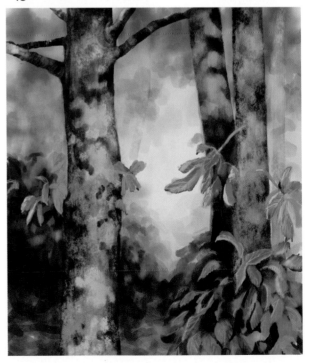

19 Switch back to the dark brown for the finishing touches. Darken the edges of the trunks again, in case these have got a little lighter with the lichen. Use the *Regular Paintbrush* to draw over the lichen in places to give it its intricate, frilly edged shape.

20 Lastly, use a thin brush to draw brown lines up and down the trunks for some finishing texture.

FINISHED ARTWORK
The path for the eye and the sharpness of the trunk edges against the hazy background create a real sense of depth.

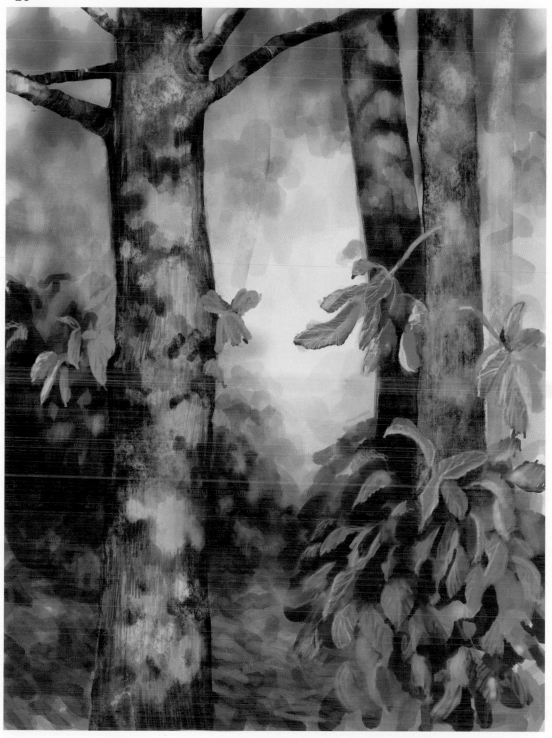

GLOSSARY

ABSTRACTION
Without using traditional representations of things, people, or landscapes, abstraction instead uses a visual language of shape, form, color, and line to create a composition. Abstract art as a genre began in the 20th century.

APP
An abbreviated form of "application," it denotes a software package for a mobile device, such as an iPad. The apps used in this book include:

• Adobe Photoshop Sketch
• ArtRage
• Art Studio for iPad
• Pen & Ink
• Procreate
• Tayasui Sketches Pro (version 2)

ARTWORK
An artwork is an aesthetic physical item or experience, made with line, shape, value, color, texture, form and space, and concepts.

ATMOSPHERIC OR AERIAL PERSPECTIVE
The illusion of depth in a painting or drawing achieved through making colors paler, bluer, and less distinct in the distance. This mimics the real-life effect of the scattering of light by particles in the air, which affects particularly long-wave blue light.

BLIND CONTOUR
A line drawing completed without looking at the drawing during its creation.

BOKEH
A Japanese term literally meaning "blur" that describes the quality of the out-of-focus area of a photograph that occurs when we use lenses to focus on a foreground.

CHROMA
Chroma is related to the "intensity" or saturation of a hue—simply put, how pure the hue is.

COMPLEMENTARY COLORS
Colors that are opposite each other on the color wheel, which create contrast when used together in an artwork.

COMPOSITION
The way things in an artwork are put together or arranged. Components of a composition include balance, variety, rhythm, movement, pattern, proportion, and emphasis, as well as proximity and contrast.

CONTOUR
The outer and inner edges of a form, as well as the edges of changes in plane, value, hue, or texture within.

CONTRAST: INTENSITY, QUANTITY, AND VALUE
Contrast is tension produced using color theory.

GESTURE DRAWING
A fast way of drawing to capture the essential movement, stance, and motion of an object or person.

GLAZE
A thin or translucent layer of paint that is applied over the top of another to modify the existing colors.

HUE
Hue refers to color.

IMPORT AND EXPORT
A photograph or image can be imported into an app, and integrated into a drawing. The artwork can be exported as an image file.

LAYERS

Layers allow you to separate an artwork into different pieces, stacked on top of each other, that can be either combined or kept separate.

LINE MODULATION

Variations in the intensity of a line to create atmospheric perspective and form.

LINEAR PERSPECTIVE

A way of depicting receding views so they appear three-dimensional on a two-dimensional surface.

NEGATIVE AND POSITIVE SPACE

Positive space describes the shape of the subject of an artwork; negative space is around and between the subjects.

OPAQUE

If paint, or an object, is "opaque," it means light cannot pass through, and therefore it looks solid.

ORTHOGONAL

Lines of perspective, parallel to the ground plane, that meet at a vanishing point.

REPRESENTATION

Artworks that depict an object, person, or scene realistically.

RULE OF THIRDS

The division of a picture plane into thirds, both vertically and horizontally, and the placement of focal points around the areas where these lines intersect, when composing an artwork.

SCALE

The size something is depicted on the picture plane, as compared to its size in real life.

SIGHTING/OBSERVATIONAL MEASURING

When drawing from life, an object is measure relative to the size of the other things around it.

SIX CATEGORIES OF LIGHT

These describe the effect of light hitting an object: cast shadow, reflected light, core shadow, shadow, light, highlight.

STYLUS

A pencil-like device that works with touch-sensitive screens, as featured on an iPad. Some styluses such as the Apple Pencil are also pressure-sensitive.

SUBTRACTIVE VS. ADDITIVE DRAWING

Subtractive drawing is done with an eraser to take away marks already there; additive drawing adds marks using a drawing tool such as charcoal or pencil.

TINTS AND SHADES

A tint is a hue with white added; a shade is a hue with black added.

TONE

The amount of gray added to a hue. This can make a hue more or less "intense."

TRANSLUCENT

Paint or an object through which light can pass.

VALUE

Value is the amount of light or dark added to a hue. Decreasing the value makes a hue lighter, and increasing the value, darker.

VANISHING POINT

The place that converging lines recede to, on the horizon, based on a person's viewpoint.

VOLUME

The appearance of three-dimensional depth.

WARM AND COOL COLORS

Colors on one side of the color wheel are warm (reds, oranges, yellows) and on the other are cool (blues, purples, greens). Cool colors seem to recede, and warm colors come forward.

INDEX

ACKNOWLEDGMENTS

I'd like to thank Zara Larcombe, for bringing this concept to me, and helping me to shape my ideas. I would also like to thank editors Frank Gallaugher and Ellie Wilson for their patient expertise guiding it into production.

I am so grateful for the loving support of my husband Daniel and our twin daughters, Zoë and Freya, who made sure I had the time I needed to work on the book.

Finally, I would like to thank two people who I still miss very much, and who influenced all aspects of my life: Professor Lisa Jardine for showing me that a woman can do anything, and my father, Clive Adams, for filling my childhood with art, science, and making.

PICTURE CREDITS

p25: (from top) *The Healing of the Cripple and Raising of Tabitha* (detail) (c.1426), Brancacci Chapel, Florence, by Masolino da Panicale; *The School of Athens* (1510), Apostolic Palace, Vatican City, by Raphael; *Chinatown* by Nikolai Lockertsen © Nikolai Lockertsen

p35: (from top) *Mother with Child* (1910), by Egon Schiele; *Untitled* (1968), by Cy Twombly © Cy Twombly Foundation. Photo: Sotheby's New York

p47: *Yellow Glass Bowl with Tangerines* (2007), by Janet Fish © Janet Fish. DACS, London/VAGA, New York, 2017. Courtesy of DC Moore Gallery

p62: *Orange Crush Can* (2016), by Susan Murtaugh © Susan Murtaugh

p63: *Candy Jars* (2008), by Margret Morrison © Margaret Morrison 2016. Courtesy of Woodward Gallery, NYC

p84: *BkLit Again* (2009), by Susan Murtaugh © Susan Murtaugh

p85: (from top) *Girl Looking Straight Out*, by Claerwen James © Claerwen James, Flowers Gallery, London and New York; *Self Portrait* (2016), by Martin Field © Martin Field, 2016, martin-field.com

p97: *Cat Cleaning Itself* (1904–08), by Gwen John © Tate London, 2015

p109: *London Girl with Balloons*, photographed Great Eastern Street, London (2004; removed 2014), by Banksy © Barry Lewis/Alamy Stock Photo

p115: *Water Lilies, 1916* (1916), by Claude Monet ©National Museum of Western Art, Tokyo/ Leemage/Bridgeman Images